Nancy Kominsky's
Joy of
Oil Painting

**A Recipe Guide to Perfect Oil Painting
for the Beginner**

Crescent Books
New York

This 1983 edition is published by Crescent Books,
distributed by Crown Publishers, Inc.

First published in Great Britain by William Collins Sons & Co Ltd
under the title *Nancy Kominsky : Oil Painting for the Beginner*.

Designed and produced by the Rainbird Publishing Group Ltd,
40 Park Street, London W1Y 4DE

Printed and bound by Henri Proost & Cie PVBA,
Turnhout, Belgium

Library of Congress Cataloging in Publication Data

Kominsky, Nancy Circelli.
 Nancy Kominsky's Joy of oil painting.

 Includes index.
 1. Painting – Technique. I. Title. II. Title :
Joy of oil painting.
ND1500.K655 1982 751.45 82-14923

ISBN 0-517-39826-5

h g f e d c b a

Contents

Foreword 5

Before you paint 7
Painting materials 7
Measurements for mixing the colours 12
Painting procedures 13
Tonal values 18
Basics for mixing the colours 18
Getting started 19
Some guidelines before mixing the colours 19

The colour mixing guide 22
Basic colour combinations 22
　Sky tones 22
　Stormy sky tones 23
　Sky at sundown 23
　Water and sea tones 24
　Earth tones 24
　Tree tones 25
　Mountain tones 25
　Rock tones 26
Mixtures for colour tones 26
　Blue tones 26
　Yellow tones 27
　Red tones 28
　Orange tones 29
　Purple tones 29
　Green tint 30
　Black tones 30
　White tones 31
Greyed background colours 31
　Greyed tones of burnt orange 31
　Greyed tones of yellow ochre 32
　Greyed tones of light green 32
　Greyed tones of dark green 33

Alternative background colours 33
Mixtures for colour tints 34
　Yellow tint 34
　Orange tint 34
　Red tint 35
　Dark red tint 35
　Lavender purple tint 36
　Blue purple tint 36
　Blue tint 37
　Green tint 37
Colour mixes for portrait painting 38
　Flesh tones 38
　Painting lips 38
　Painting eyes 38
　Painting hair 39

Paintings to practise 40
Apples 40
Pears 44
Oranges 46
Spring bouquet 48
Colour combinations for other floral paintings 55
Landscape – Reflections 56
Landscape – Field of poppies 58

Index 63
Artists' materials 63
Paints 63
Landscape 63
Seascape 63
Portraits 63
Still life 63
Fruit 64
Vegetables 64
Flowers 64

Nancy Kominsky

Nancy Kominsky, a native Philadelphian, is a portrait painter, an international lecturer, teacher and author, who now lives in Rome, Italy. She studied at the Graphic Sketch Club, Philadelphia, Pa. Cooper Union, New York City and under Theodore Lukits, a well-known portrait painter in California. She worked for three years doing painting and sculpturing on scaled dioramas for a Pennsylvania Museum.

In 1963, faced with the prospect of no income and at the urging of a friend, she opened her first Sunday Painters Art Studio in Burbank, California. She devised a unique 'anyone can paint' system of teaching which became instantly successful.

In 1966 she moved to Rome and opened the equally successful Sunday Painters of Rome, teaching personnel from all the embassies of the world how to paint. She has completed four highly acclaimed networked television series in Britain, of thirteen programmes each, called *Paint Along with Nancy* which is being re-screened throughout 1982, and has written very successful accompanying books. The Nancy Kominsky television series has also been shown very successfully in the United States.

Foreword

You would like to paint but don't know where to start, so what is the first thing to do? Or, you have a photograph of a favourite vacation spot that you would like to capture on canvas but you are an absolute beginner.

It has been my experience in years of teaching that the most frustrating aspect of learning to paint is mixing colour, even more than the drawing. In a painting colour is vitally important. Even Delacroix believed that colour, not draughtsmanship, is the basis of painting. Therefore, I have decided to remove the mystique from mixing colour with this step-by-step productive approach with guaranteed results on your very first attempt.

This unique and complete colour mixing guide will fulfil almost all your colour needs, and will be as invaluable a tool to you, the beginner painter, as a dictionary is to a writer. For example, you want to paint that vacation scene, a landscape, from a photograph. After you have prepared your prescribed painting materials and read the preliminary instructions, turn to page 58 for explicit directions on how to transfer a photograph, postcard or even a painting to canvas. Refer to the index for the subject you need – sky, trees, rocks or any other objects in your landscape. The index will then refer you to a particular colour mix which gives exact amounts of paint to use as in a recipe. This takes all the guesswork out of mixing colours.

Until you have mastered the simple mechanics of painting, the choice of subject is extremely important. Keep it simple. I would suggest that people and animals should not be attempted at first and to avoid frustrations and to continue painting, resist the temptation to paint 'Little Susie' or 'Rover' for now. It is much better to start with still life and landscapes. You can practise with fruits and vegetables from your own kitchen, flowers from the garden and any other objects in your home, no matter how mundane. Van Gogh painted marvellous studies of his old shoes, hat, pipe and pottery which are just as famous as his 'Potato Eaters' and 'Sunflowers'. So there should be no question of what to paint!

Happy Painting!

Nancy Kominsky

5

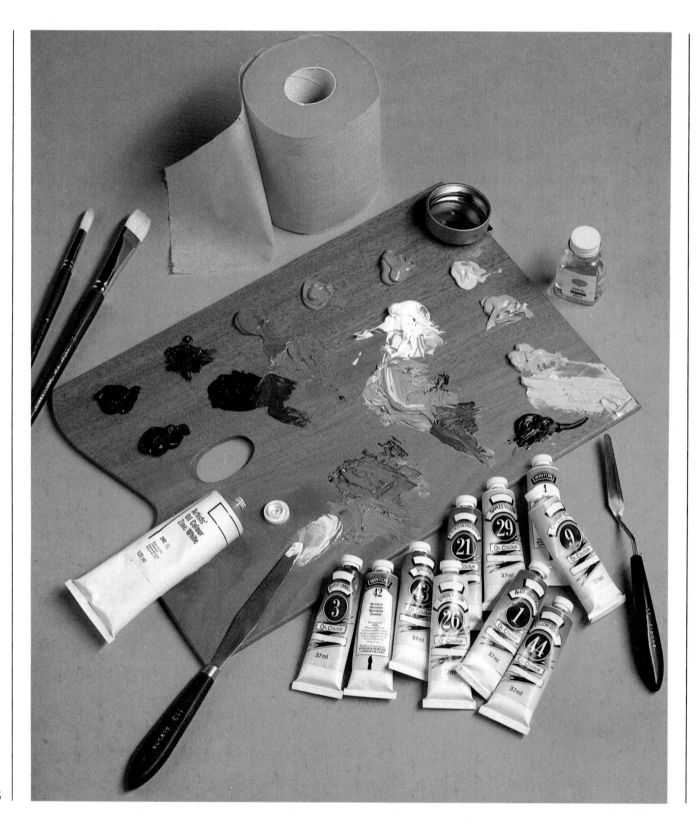

Before you paint

PAINTING MATERIALS
The following is a list of colours and other required painting materials.

1. Paints
The names of the colours used in this list of oil paints are universal ones and apply to most manufacturers throughout the world. The best size to buy is the 4-inch No. 14 (38 ml) tube of oil paint. Keep to the same colours as those recommended or else your colour mixes will vary from the mixing guides shown in this book.

Lemon Yellow
Cadmium Yellow Deep
Naples Yellow
Yellow Ochre
Cadmium Orange
Alizarin Crimson
Vermilion
Viridian (green)
Burnt Umber
French Ultramarine (blue)
Extra large tube of Zinc or Flake White,
 the 6-inch No. 40 (115 ml) size

Almost twice as much white is needed because it is used in the mixing of every colour, especially the light tones and objects such as sky, water or snow. There is very little difference between Zinc and Flake White. Zinc White, however, does not dry as rapidly and is easier to use in mixing colour. Both Zinc and Flake White are universal names.

2. Palette knives

(a) *Offset knife:* this is the same as the painting knife. The small elevation at the base of the handle keeps the fingers out of the paint while in use. In painting the offset knife is held lightly and the paint stroked on usually with the flat of the knife.

How to hold an offset knife

(b) *Straight knife*: this is used for mixing colours. The mixture of paint is simply turned over and over while mixing but make sure that the pile of paint is kept contained and doesn't spread all over the palette.

3. Brushes

(a) If you are painting with a knife you will also need the following brushes:

● One No. 12 or No. 10 – a flat, hog bristle brush. This is used for the umber wash.
● One No. 8 or No. 6 – a medium, round, hog bristle brush. This is used for the drawing.

(b) If you are painting with a brush rather than with a knife, you will need the same brushes as mentioned above as well as the following:

● One No. 2 or No. 4 – a flat, hog bristle brush.
● One No. 2 or No. 4 – a round, sable brush.

In brush painting, the smaller-size sable brushes are best. As you progress, you will probably want to add more brushes to your range.

4. Turpentine

This is used not only for the umber wash and the drawing, but also for cleaning the palette, brushes and one's fingers. White spirit or kerosene can also be used if you do not like the smell of turpentine – these solvents are practically odourless.

5. Palette

A large square wooden palette, approximately 12 by 16 inches (30 by 41 cm) is the best. (You can also buy large tear-off palette pads which have the advantage of being disposable after each painting.) A wooden palette of this size, especially with the paint on it, is too heavy to hold and so it doesn't matter if you are right or left handed. Simply place the palette on a flat surface to the right or to the left of the easel. If you are painting with a knife you need both hands free to be able to keep on cleaning the knife as you paint.

6. Single-tin dipper

A large single-tin dipper is needed to hold the turpentine.

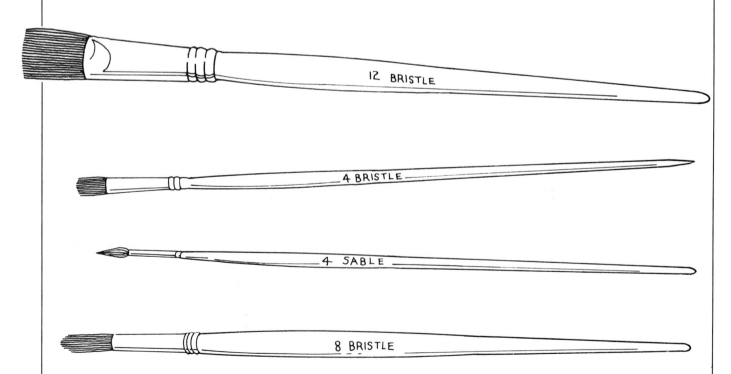

A selection of brushes used for painting

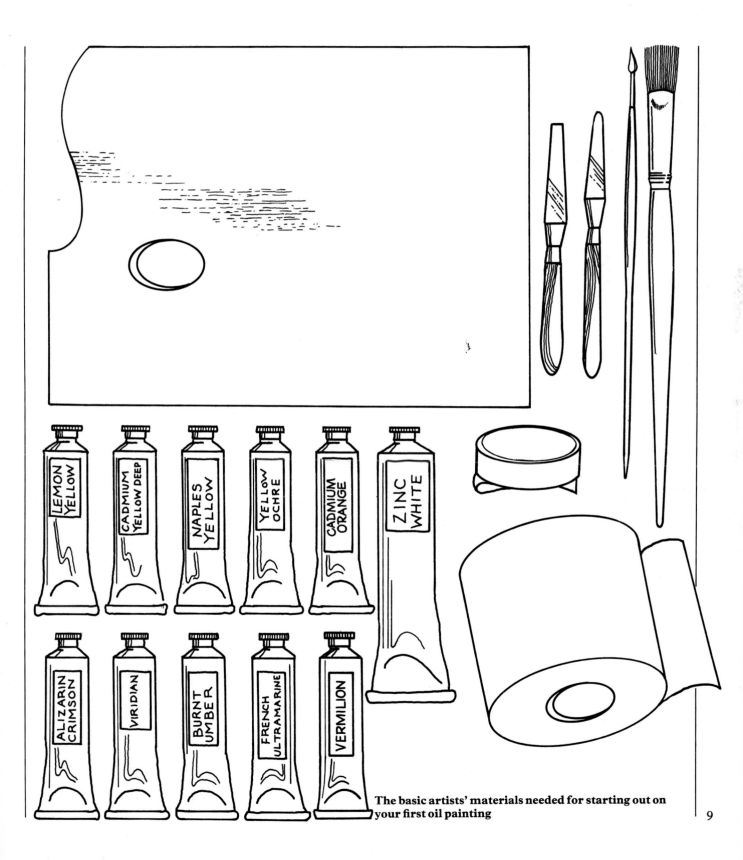

**The basic artists' materials needed for starting out on
your first oil painting**

LEMON YELLOW

CADMIUM YELLOW DEEP

NAPLES YELLOW

YELLOW OCHRE

CADMIUM ORANGE

ZINC WHITE

ALIZARIN CRIMSON

VIRIDIAN

BURNT UMBER

FRENCH ULTRAMARINE

VERMILION

7. Toilet tissue

This is cheaper than cotton rag and has the advantage of being disposable. It is used to wipe the excess moisture from the umber wash and to wipe out mistakes in the drawing. It is also essential for cleaning the knife during painting and to clean the palette after scraping off the paint.

8. A plastic litter bag

9. Canvas or canvas boards

Use any one of the following, 14 by 18 inches (36 by 46 cm).

(a) *Stretched canvas:* until you are more experienced, buy cotton canvas which has already been stretched. Do not buy primed canvas as this is very expensive. A beginner to oil painting should not attempt to stretch his own canvas as a badly stretched canvas will result in ripples on the surface. You will also need to buy a special tool and stretcher frames amongst other things.

(b) *Canvas board:* this is excellent for a beginner as it is inexpensive.

(c) *Hardboard:* this is the least expensive material, especially for very large paintings. The texture is interesting and it can be bought at any timber merchant. Use the rough side of the board. If painting with a brush, cover the board with several coats of household undercoat paint (acrylic emulsion). If using a knife to paint with, it is probably not necessary to undercoat, in which case you can draw straight onto the hardboard with chalk.

10. Easel

Use whatever is available but make sure that it is sturdy. A table easel is very useful if you are short of storage space as not only does it fold away but the table on which you place the easel provides a good surface on which to put all your painting equipment, such as palette and knives.

11. Cling film or tin foil

Use either of these to cover any leftover paint on the palette. If you put the palette in the fridge the paint will keep indefinitely. You can also put any piles of leftover mixed paint in a tin foil dish, cover and put in your freezer.

12. Artists' clear picture varnish

Six months after the painting is completed, dust it off with a soft, dry brush. Apply the clear varnish lightly with a large, flat brush. Lay the painting flat until it is dry. This is to avoid 'tears' of varnish running down the canvas. The varnish will take about an hour to dry.

13. Where to paint

The ideal place to paint is in a north-facing room but most people make do with a corner of any room that is spare and use electric rather than natural light. Natural light is preferable, but the important thing is to have space to move about in and to be comfortable. After all, painting is supposed to be enjoyable.

A selection of easels

Table easel

Studio easel

Folding easel

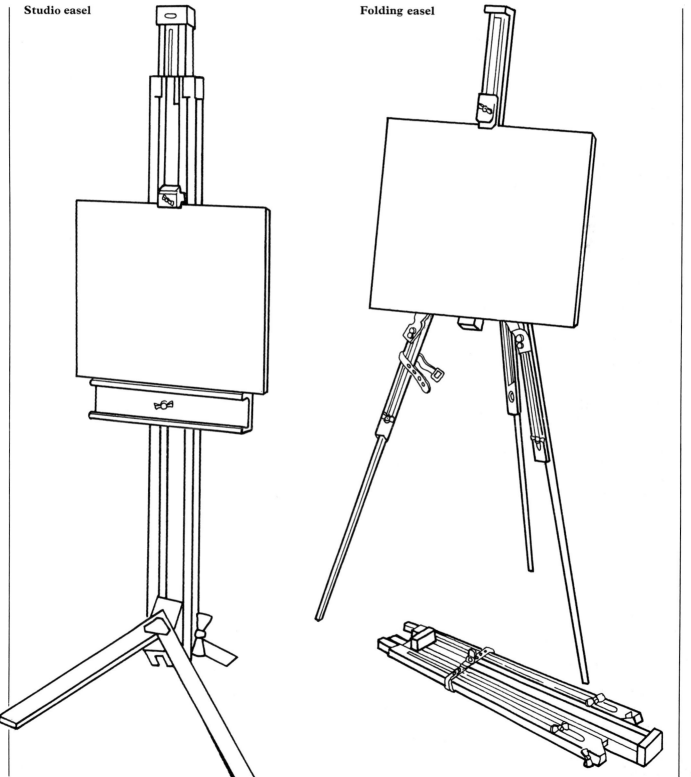

MEASUREMENTS FOR
MIXING THE COLOURS

1. In an oil painting, colour is the most important thing to consider, far more than the drawing. In the colour mixing guide, I have broken down each mixture into precise amounts of colour needed, just like the ingredients of a cookery recipe. For measuring out the different quantities of paint, I have used the idea of spoons. Don't actually measure the paint out onto the palette with spoons but use the drawings below to judge how much paint you need to squeeze from the tube.

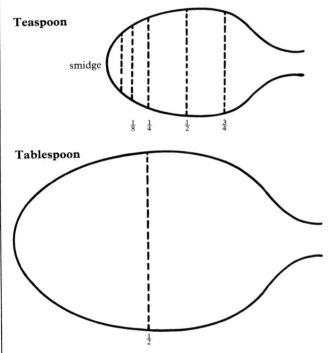

Teaspoon

smidge

$\frac{1}{8}$ $\frac{1}{4}$ $\frac{1}{2}$ $\frac{3}{4}$

Tablespoon

$\frac{1}{2}$

These different amounts apply mostly to knife painting as this uses up more paint. The exact quantities for mixing a colour ensure that you have sufficient for each area of the painting. You can end up using just as much paint by mixing bits here and there which is a time-consuming nuisance.

2. Always try to keep your pile of mixed paint clean. If you have any mixed paint left over when you have finished painting, remove it from the mixing area and place it neatly at the edge of the palette.

3. Next, clean the mixing area before mixing another colour. To do this, scrape the mixing area with a straight knife and wipe it clean with turpentine or another solvent and toilet tissue. The mixing area must be left clean after each session.

PAINTING PROCEDURES

1. Before applying the oil paint to the canvas, you must cover it with an umber wash. This is called underpainting and gives the finished painting a richer colour. The damp canvas also allows you to wipe off any mistakes in the drawing with toilet tissue as you go along.

To make the umber wash, squeeze out ½ teaspoonful of Burnt Umber onto the mixing area of the palette. Dip the large, flat, bristle brush into the turpentine, making sure that it does not drip, and then dip the brush into the Burnt Umber on the palette, pulling some aside with the brush to make a light, rather thin wash.

Cover the canvas with the umber wash but take care not to make it too dark or too runny. Wipe off any excess moisture with toilet tissue but leave the canvas damp.

2. To divide the canvas up into sections, use the medium round brush and umber wash. Use slightly more Burnt Umber than turpentine this time in order to achieve a darker colour wash.

If your canvas is to be used vertically, draw three vertical lines equally spaced and five horizontal lines. If the canvas is to be used horizontally, draw five equally spaced vertical lines and three horizontal lines. When doing this, a useful tip is to divide the canvas into quarters first, then divide each section as indicated. If your canvas is square, draw three equally spaced vertical lines and three equally spaced horizontal lines. The sections do not have to be measured exactly. This method of sectioning-off the canvas can be used for any size canvas. In a larger canvas, the squares will be larger but so will the scale of the drawing.

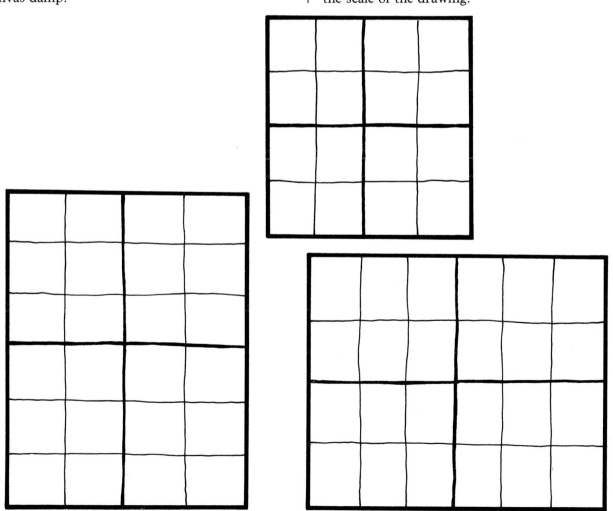

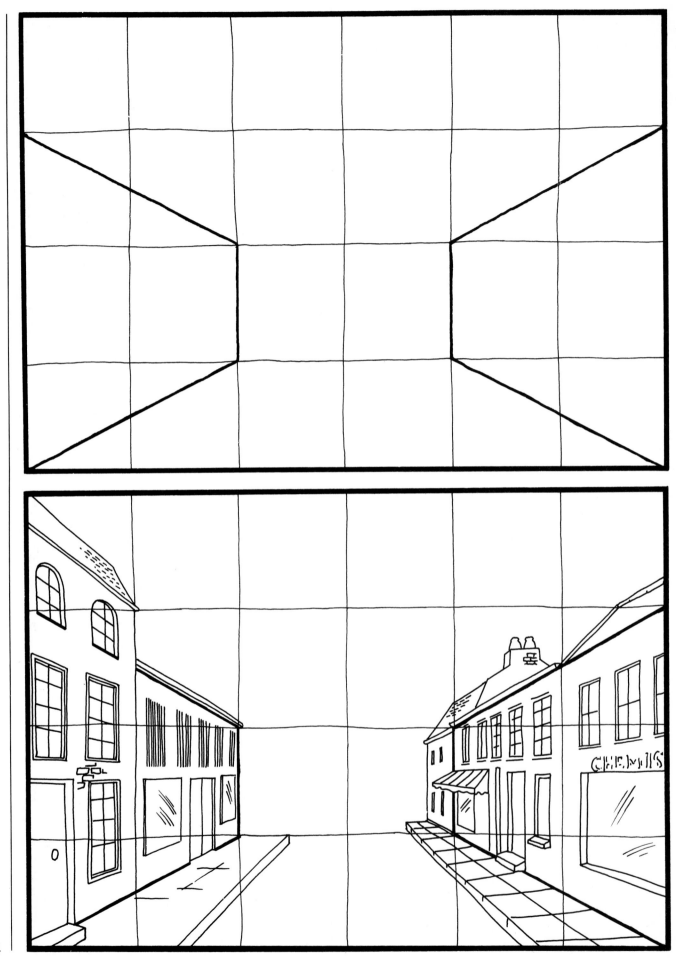

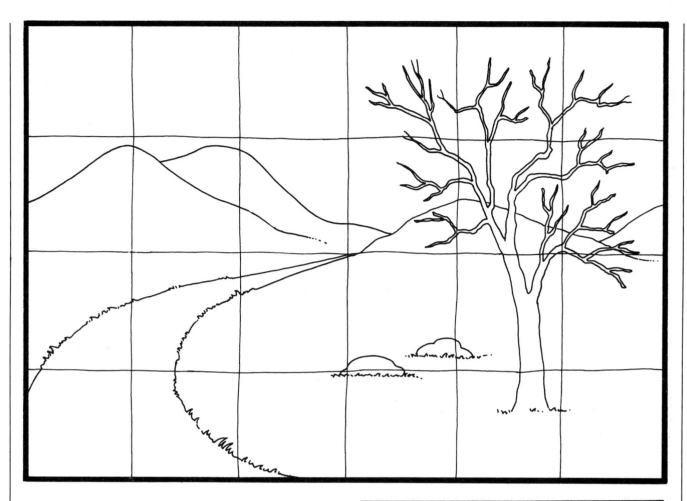

3. In placing work on the canvas, start at the bottom and mark a place for the objects before drawing them in. This helps with correct placement and sizing. Use the squares as guidelines, they are invaluable in street scenes and anywhere else where perspective is used. Put objects, such as vases, in a box, again using the squares as guidelines, to make sure that both sides are equal.

4. Put in the rough drawing with the medium round brush and umber wash. Ignore any detail of the subject matter for the time being: do not put petals on flowers yet, nor leaves on trees and rigging on boats. The details will be painted in later.

full

profile

buds

other angles

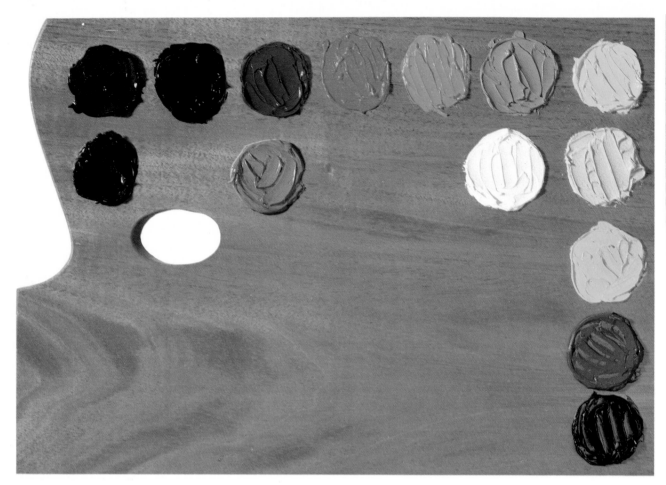

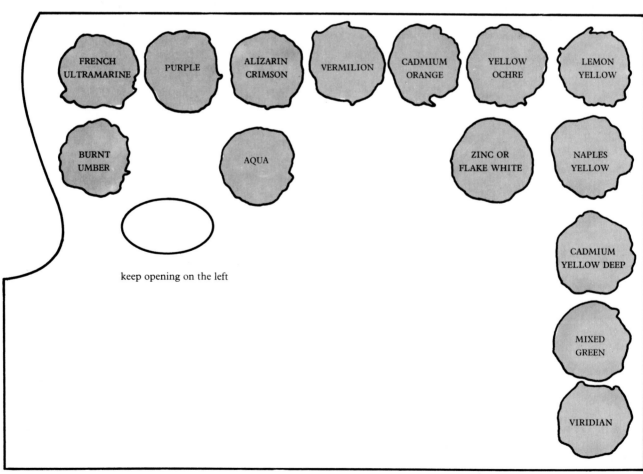

FRENCH ULTRAMARINE

PURPLE

ALIZARIN CRIMSON

VERMILION

CADMIUM ORANGE

YELLOW OCHRE

LEMON YELLOW

BURNT UMBER

AQUA

ZINC OR FLAKE WHITE

NAPLES YELLOW

CADMIUM YELLOW DEEP

MIXED GREEN

VIRIDIAN

keep opening on the left

5. The most important thing, before mixing the colour, is to decide where the light is coming from in a painting and then to loosely add shading where the shadows will be. Continue to be conscious of light and shadow until the last stroke has been added. The light usually falls from one particular side. If in doubt, check the shadows on your subject – if they are on the left, the light is coming from the righthand side and vice versa.

6. Set up your palette as shown in the drawing opposite, squeezing out about a teaspoonful of each colour. The colour mixtures of aqua, purple and mixed green should be made up as indicated below.

(a) *Aqua:* mix together $\frac{1}{2}$ teaspoonful Viridian and I teaspoonful Zinc or Flake White.
(b) *Purple:* mix together $\frac{1}{2}$ teaspoonful Alizarin Crimson and $\frac{1}{2}$ teaspoonful French Ultramarine.
(c) *Mixed green:* mix together I teaspoonful Cadmium Yellow and $\frac{1}{2}$ teaspoonful Viridian.

7. The paint should be laid out on the palette in the same order each time so that it soon becomes easy to find the right colour. The order of colour shown on the palette works for both right- and left-handed people.

8. Be accurate when mixing your colours. You may find that your colour mixes vary slightly from the colour swatches shown in this book but this is due to the limitations of colour printing. Just make sure you keep the tonal values correct, such as keeping the extra light lighter than the light tone.

9. Keep your paint on the palette clean while working by cleaning your knife with turpentine before going from one colour to the next.

10. Always use a straight knife for mixing paint. Using a brush will ruin it and makes the brush too thick to give clean strokes.

How to create the effect of mountains using the flat of the offset knife

The flat of the offset knife can also be used for painting leaves and flowers

11. If you are painting with a brush, just pick up the paint on the brush, apply to the canvas and stroke it on in the form of the object being painted – for example, use round strokes for round objects. The drawings above show how the shape of the strokes affects the final painting. Don't just fill in empty spaces. You are creating a form. Always be conscious of the shape of the object you are painting. This applies also to the application of paint with the palette knife.

Facing page: the order of paints on the palette

TONAL VALUES

The following are the basic cool and warm colours: (This does not refer to tints derived from these colours.)

Warm: yellow, red and orange
Cool: blue, green and purple
Primary colours: blue, red and yellow

You can make all other colours from primary colours. For example, blue and yellow make green. Cool colours tend to grey or cool the warm colours and vice versa. Use the complementary or greying colour sparingly.

Warm colours advance into the foreground of a painting and are more intense. Cool colours recede into the background and become cooler and paler with bluish and purple overtones.

BASICS FOR MIXING COLOURS

1. Each area on the canvas (background, objects etc) is broken down into at least three tonal values: light, medium and dark. As you become more experienced, two additional tones or more are added in polishing the painting, including the brightest highlight and accenting the shadow.

2. The medium, or mother colour (the general colour of the object) is mixed first.

3. Divide the medium colour into three piles – one small ($\frac{1}{2}$ teaspoonful) for the light tone and two piles of equal size.

4. To the small or light tone, add twice as much white and nearly always a smidge of Naples Yellow. See each colour mixing guide for specific instructions on which colours need a smidge of Naples Yellow. The touch of yellow prevents the light tone from becoming chalky and lifeless.

5. Do not touch the middle tone.

6. To the dark, or third tone, add purple or another darkening agent – not Burnt Umber. Easy does it. If the original colour of the dark tone is lost or muddied in the mixing by adding too much purple, add some of the colour used for the middle or medium tone. This restores the original colour but retains the dark of the third tone.

7. Do not add purple as a general rule to sky and sea colours.

GETTING STARTED

1. Paint in the dark tones first, followed by the middle tones and then the light tones. Only mix tones where they meet so as not to lose tonal values or muddy the colours. This is very important to preserve the contrast between light and dark in the paintings.

2. The medium and dark colours are used in the shadows of the painting. In the light area, the medium and light tones of colour are used. Again, please remember that colours must blend at the edges where they meet.

3. Work your paintings in the following order:

Landscape and seascape: paint the background or sky first. Always put light tone at the horizon, followed by the middle tone and then the dark tone at the top. Put in the ground colour, trees and other objects last. Use the offset knife for painting in the colour.

Still life: paint in the background first. Next paint in the foreground and then the vase or whatever is the subject of the painting. Lastly add the flowers and details to the vase.

SOME GUIDELINES BEFORE MIXING THE COLOURS

1. Read all the directions carefully. Mix the colours as directed with a straight knife. Remember to keep the knife clean when going from one colour to another.

2. There should be a distinct difference in tonal values. Mix the colours in the order given but don't panic if the colours don't look exactly like the colour swatches in this book. There will be slight variations due to the limitations of colour printing.

3. The colour mixes given are mixed in amounts adequate for a small canvas. A 14 by 18 inch (36 by 46 cm) canvas is an excellent size for beginners and avoids the constant mixing and matching of dabs of paint to cover the canvas.

4. Some areas in a painting will not use up all the paint mixture made up. Do not throw away the paint but transfer the blobs to a shallow tin foil dish, cover lightly with cling film and put in the freezer. It will stay fluid and keep for ever. You can use this extra paint on a smaller canvas later.

5. All highlight used in painting fruits, vegetables, vases and glass is one basic mixture.
Make up the highlight as follows:
¾ teaspoon White
smidge of Naples Yellow
This highlight can also be used for sea foam.

6. All the following colour mixes can be used for objects and areas in any painting, for example:

Tones of white: snow, clouds, vases, flowers, buildings.
Tones of green: foliage, shrubs, grass, vases, trees and vegetables.
Greyed burnt orange: backgrounds, copper, barns, brick, roofs and vases.

After deciding on your subject, you will find that you can use or adapt any colour from the colour mixing guide in this book to suit your particular needs and in exact amounts to take the guesswork out of mixing colour. Use the index to find the right colour.

7. Glass

Painting glass is not as mysterious or difficult as it seems at first. After drawing in the outlines of the clear glass vase, paint in the background colour of the painting, painting between the outlines of the vase, making sure that you keep the outline clear. If there are flowers in the vase, paint in the stems in the vase on the background colour. Outline the glass lightly in purple and add highlights wherever necessary.

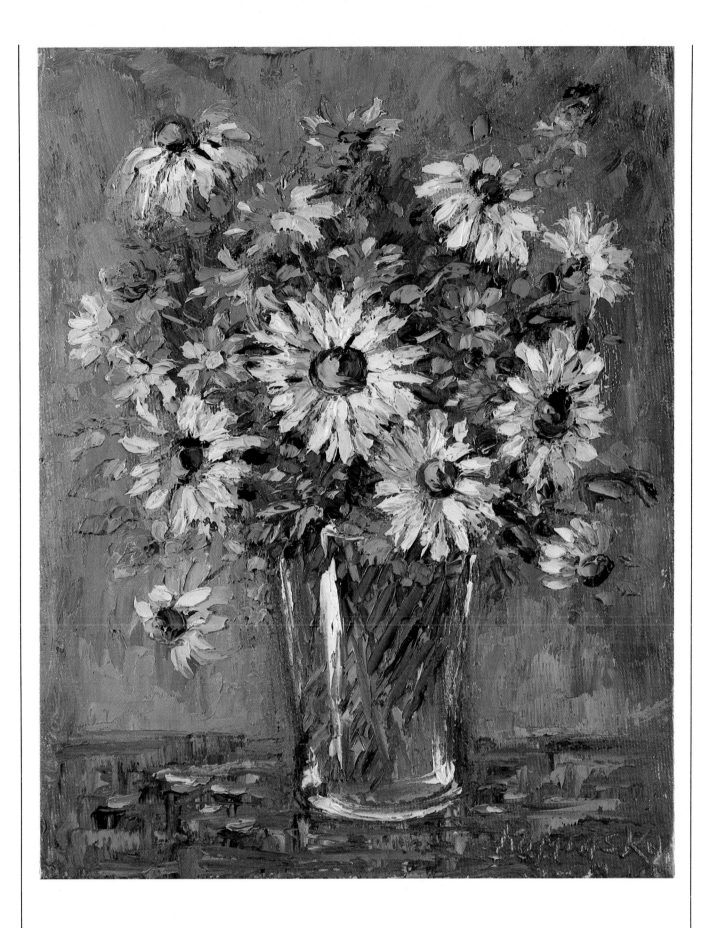

The colour mixing guide

Colour mix for sky tones

EXTRA LIGHT

LIGHT

MEDIUM

DARK

MEDIUM TONE
$1\frac{1}{4}$ tablespoons White
$\frac{1}{4}$ teaspoon French Ultramarine
$\frac{1}{2}$ teaspoon aqua
smidge Cadmium Orange (easy does it)

Mix the paint and separate it into three parts, one small ($\frac{1}{2}$ teaspoon) and two equal parts.

1. LIGHT TONE
Use the first part ($\frac{1}{2}$ teaspoon).
Add: 1 teaspoon White
$\frac{1}{8}$ teaspoon Naples Yellow

2. MEDIUM TONE
Use the second part. Leave it as it is.

3. DARK TONE
Use the third part.
Add: $\frac{1}{8}$ teaspoon French Ultramarine
$\frac{1}{4}$ teaspoon aqua
smidge Cadmium Orange
smidge purple

4. EXTRA LIGHT TONE
When this is required, to $\frac{1}{2}$ teaspoon light tone
Add: $\frac{1}{2}$ teaspoon White
smidge Naples Yellow
This is used in all skies at the horizon.

● In order to make a rosy tone for the sky at the horizon, add a smidge of orange to the extra light sky tone. The light and extra light sky tones are mostly painted on the horizon.

Colour mix for stormy sky tones

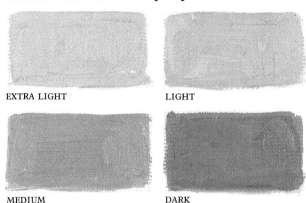

EXTRA LIGHT LIGHT

MEDIUM DARK

MEDIUM TONE
$1\frac{1}{4}$ tablespoons White
$\frac{1}{4}$ teaspoon French Ultramarine
$\frac{1}{2}$ teaspoon of aqua
$\frac{1}{4}$ teaspoon Cadmium Orange

Mix the paint and separate it into three parts, one small ($\frac{1}{2}$ teaspoon) and two equal parts.

1. LIGHT TONE
Use the first part ($\frac{1}{2}$ teaspoon)
Add: 1 teaspoon White
 $\frac{1}{8}$ teaspoon Naples Yellow

2. MEDIUM TONE
Use the second part: leave it as it is.

3. DARK TONE
Use the third part
Add: $\frac{1}{8}$ teaspoon French Ultramarine
 $\frac{1}{4}$ teaspoon aqua
 smidge Cadmium Orange
 smidge purple

4. EXTRA LIGHT TONE
When this is required, to $\frac{1}{2}$ teaspoon light tone
Add: $\frac{1}{2}$ teaspoon White
 smidge Naples Yellow

The colours will be greyish. Paint storm clouds with the medium and dark tones.

Colour mix for sky at sundown

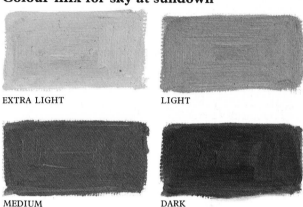

EXTRA LIGHT LIGHT

MEDIUM DARK

MEDIUM TONE
$1\frac{1}{2}$ teaspoons White
$\frac{1}{2}$ teaspoon Yellow Ochre
$\frac{1}{8}$ teaspoon purple
$\frac{1}{4}$ teaspoon Cadmium Orange

Mix the paint and separate it into three parts, one small ($\frac{1}{2}$ teaspoon) and two equal parts.

1. LIGHT TONE
Use the first part ($\frac{1}{2}$ teaspoon)
Add: 1 teaspoon White
 $\frac{1}{8}$ teaspoon Naples Yellow
 $\frac{1}{8}$ teaspoon Cadmium Orange

2. MEDIUM TONE
Use the second part. Leave it as it is.

3. DARK TONE
Use the third part
Add: $\frac{1}{4}$ teaspoon purple
 $\frac{1}{8}$ teaspoon Alizarin Crimson
 $\frac{1}{8}$ teaspoon Cadmium Orange

4. EXTRA LIGHT TONE
When this is required, to $\frac{1}{2}$ teaspoon light tone
Add: $\frac{1}{2}$ teaspoon White
 smidge Naples Yellow

Colour mix for water and sea tones

EXTRA LIGHT

LIGHT

MEDIUM

DARK

Colour mix for earth tones

LIGHT

MEDIUM

DARK

EXTRA DARK

MEDIUM TONE
$1\frac{1}{4}$ tablespoons White
$\frac{1}{4}$ tablespoon French Ultramarine
$\frac{1}{8}$ teaspoon mixed green
smidge Cadmium Orange (easy does it)

Mix the paint and separate it into three parts, one small ($\frac{1}{2}$ teaspoon) and two equal parts.

1. LIGHT TONE
Use the first part ($\frac{1}{2}$ teaspoon).
Add : 1 teaspoon White
$\frac{1}{8}$ teaspoon Naples Yellow

2. MEDIUM TONE
Use the second part. Leave it as it is.

3. DARK TONE
Use the third part.
Add : $\frac{1}{8}$ teaspoon French Ultramarine
$\frac{1}{4}$ teaspoon aqua
smidge Cadmium Orange
smidge purple

4. EXTRA LIGHT TONE
When this is required, to $\frac{1}{2}$ teaspoon light tone
Add : $\frac{1}{2}$ teaspoon White
smidge Naples Yellow

When painting water, remember that it is the reflection of the sky so water and sea tones are basically sky tones with some green added. Remember that water is shallower nearer the shore and therefore is lighter in colour.

● For sea foam use the following highlight mixture:
$\frac{3}{4}$ teaspoon White
smidge Naples Yellow (easy does it)

MEDIUM TONE
1 tablespoon Yellow Ochre
$\frac{1}{2}$ teaspoon White
$\frac{1}{8}$ teaspoon Cadmium Orange

Mix the paint and separate it into three parts, one small ($\frac{1}{2}$ teaspoon) and two equal parts.

1. LIGHT TONE
Use the first part ($\frac{1}{2}$ teaspoon)
Add : $\frac{3}{4}$ teaspoon White
$\frac{1}{2}$ teaspoon Naples Yellow

2. MEDIUM TONE
Use the second part. Leave it as it is.

3. DARK TONE
Use the third part.
Add : $\frac{1}{4}$ teaspoon purple
smidge mixed green

4. EXTRA DARK TONE
When this is required, to $\frac{1}{2}$ teaspoon dark tone
Add : $\frac{1}{8}$ teaspoon purple

Colour mix for tree tones

LIGHT

MEDIUM

DARK

EXTRA DARK

MEDIUM TONE
$\frac{1}{2}$ teaspoon Burnt Umber
$\frac{1}{2}$ teaspoon Yellow Ochre
$\frac{1}{4}$ teaspoon purple
$\frac{1}{8}$ teaspoon Cadmium Orange

Mix the paint and separate it into three parts, one small ($\frac{1}{2}$ teaspoon) and two equal parts.

1. LIGHT TONE
Use the first part ($\frac{1}{2}$ teaspoon).
Add: $\frac{1}{2}$ teaspoon White
$\frac{1}{4}$ teaspoon Naples Yellow
smidge Cadmium Orange

2. MEDIUM TONE
Use the second part. Leave it as it is.

3. DARK TONE
Use the third part.
Add: $\frac{3}{4}$ teaspoon purple
$\frac{1}{4}$ teaspoon Cadmium Orange

4. EXTRA DARK TONE
When this is required, use purple from the palette. This tone is usually used for slender trees.

The tree tone is used for trees and branches, usually when they are in the foreground.

Colour mix for mountain tones

EXTRA LIGHT

LIGHT

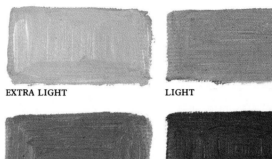
MEDIUM

DARK

MEDIUM TONE
1 teaspoon White
$\frac{1}{2}$ teaspoon purple
$\frac{1}{8}$ teaspoon Yellow Ochre
smidge mixed green

Mix the paint and separate it into three parts, one small ($\frac{1}{2}$ teaspoon) and two equal parts.

1. LIGHT TONE
Use the first part ($\frac{1}{2}$ teaspoon).
$\frac{1}{8}$ teaspoon Naples Yellow

2. MEDIUM TONE
Use the second part. Leave it as it is.

3. DARK TONE
Use the third part.
Add: $\frac{1}{8}$ teaspoon French Ultramarine
$\frac{1}{8}$ teaspoon purple
$\frac{1}{8}$ teaspoon aqua
smidge Cadmium Orange

4. EXTRA LIGHT TONE
When this is required, to $\frac{1}{2}$ teaspoon light tone.
Add: $\frac{1}{2}$ teaspoon White
smidge Naples Yellow
smidge Cadmium Orange

If the mountains are in the far distance, the dark tone of the sky can be used. This is effective against the extra light sky tone at the horizon.

● For snow-capped mountains mix light and medium tones of white. With your offset knife, paint the light tone where indicated and then paint the medium tone where the shadows appear. Do not cover the mountains entirely with snow as there are usually rocks showing in parts.

25

Colour mix for rock tones

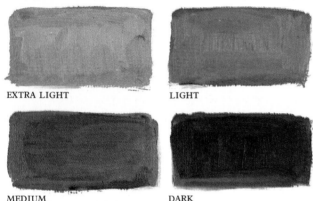

EXTRA LIGHT LIGHT

MEDIUM DARK

Colour mix for blue tones

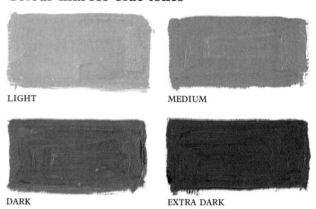

LIGHT MEDIUM

DARK EXTRA DARK

MEDIUM TONE
$\frac{3}{4}$ teaspoon White
$\frac{1}{2}$ teaspoon purple
$\frac{1}{2}$ teaspoon Yellow Ochre
smidge mixed green

Mix the paint and separate it into three parts, one small ($\frac{1}{2}$ teaspoon) and two equal parts.

1. LIGHT TONE
Use the first part ($\frac{1}{2}$ teaspoon).
Add : $\frac{1}{2}$ teaspoon White
$\frac{1}{4}$ teaspoon Naples Yellow
smidge Cadmium Orange

2. MEDIUM TONE
Use the second part. Leave it as it is.

3. DARK TONE
Use the third part.
Add : $\frac{3}{4}$ teaspoon purple
smidge mixed green

4. EXTRA LIGHT
When this is required, to $\frac{1}{2}$ teaspoon light tone
Add : $\frac{1}{2}$ teaspoon White
smidge Naples Yellow

Mixtures of greyed dark green on page 33 can also be used if desired.

MEDIUM TONE
1 teaspoon White
$\frac{1}{2}$ teaspoon French Ultramarine
$\frac{3}{4}$ teaspoon aqua
smidge Cadmium Orange

Mix the paint and separate it into three parts, one small ($\frac{1}{2}$ teaspoon) and two equal parts.

1. LIGHT TONE
Use the first part ($\frac{1}{2}$ teaspoon).
Add : $\frac{1}{4}$ teaspoon aqua
$\frac{1}{2}$ teaspoon White
smidge Naples Yellow

2. MEDIUM TONE
Use the second part. Leave it as it is.

3. DARK TONE
Use the third part.
Add : $\frac{1}{4}$ teaspoon French Ultramarine
$\frac{1}{4}$ teaspoon aqua
smidge Cadmium Orange

4. EXTRA DARK TONE
When this is required, to $\frac{1}{2}$ teaspoon light tone
Add : $\frac{1}{2}$ teaspoon French Ultramarine

Colour mix for yellow tones

LIGHT

MEDIUM

DARK

EXTRA DARK

MEDIUM TONE
$1\frac{1}{4}$ teaspoons Cadmium Yellow Deep only

Separate the Cadmium Yellow Deep into three parts, one small ($\frac{1}{2}$ teaspoon) and two equal parts.

I. LIGHT TONE
Use the first part ($\frac{1}{2}$ teaspoon).
Add: $\frac{1}{2}$ teaspoon White
\qquad $\frac{1}{2}$ teaspoon Lemon Yellow

2. MEDIUM TONE
Use the second part. Leave it as it is.

3. DARK TONE
Use the third part.
Add: $\frac{1}{2}$ teaspoon Yellow Ochre
\qquad $\frac{1}{8}$ teaspoon purple

4. EXTRA DARK TONE
When this is required, to $\frac{1}{2}$ teaspoon dark tone
Add: $\frac{1}{2}$ teaspoon Yellow Ochre
\qquad $\frac{1}{4}$ teaspoon purple

Alternative tones of yellow

EXTRA LIGHT (LEMON YELLOW)

LIGHT (NAPLES YELLOW)

MEDIUM (CADMIUM YELLOW DEEP)

DARK (YELLOW OCHRE)

The above combination of yellows creates effective tonal values. These tones are useful for painting fruit and flowers. Use the colour straight from the palette unmixed.

Colour mix for red tones

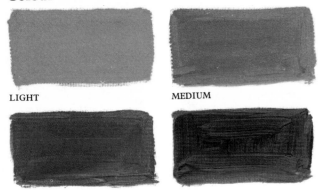

LIGHT MEDIUM

DARK EXTRA DARK

MEDIUM TONE
$1\frac{3}{4}$ teaspoons Vermilion only.

Separate the Vermilion into three parts, one small ($\frac{1}{2}$ teaspoon) and two equal parts.

1. LIGHT TONE
Use the first part ($\frac{1}{2}$ teaspoon).
Add: $\frac{1}{4}$ teaspoon Cadmium Orange
 $\frac{3}{4}$ teaspoon White
 $\frac{1}{8}$ teaspoon Vermilion

2. MEDIUM TONE
Use the second part. Leave it as it is.

3. DARK TONE
Use the third part.
Add: $\frac{1}{2}$ teaspoon Alizarin Crimson

4. EXTRA DARK TONE
When this is required, to $\frac{1}{2}$ teaspoon dark tone
Add: $\frac{1}{2}$ teaspoon Alizarin Crimson

Alternative tones of red

LIGHT (CADMIUM ORANGE)

MEDIUM (VERMILION)

DARK (ALIZARIN CRIMSON)

The above combination of reds creates effective tonal values. These tones are useful for painting fruit and flowers. Use the colours straight from the palette unmixed.

Colour mix for orange tones

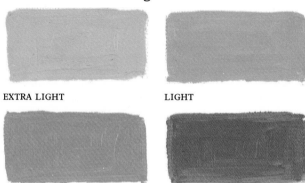

EXTRA LIGHT LIGHT

MEDIUM DARK

MEDIUM TONE
$1\frac{3}{4}$ tablespoons Cadmium Orange only

Separate the Cadmium Orange into three parts, one small ($\frac{1}{2}$ teaspoon) and two equal parts.

1. LIGHT TONE
Use the first part ($\frac{1}{2}$ teaspoon).
Add: $\frac{1}{2}$ teaspoon White
 $\frac{1}{4}$ teaspoon Cadmium Yellow Deep

2. MEDIUM TONE
Use the second part. Leave it as it is.

3. DARK TONE
Use the third part.
Add: $\frac{3}{4}$ teaspoon Alizarin Crimson

4. EXTRA LIGHT TONE
When this is required, to $\frac{1}{2}$ teaspoon light tone
Add: $\frac{1}{2}$ teaspoon White
 $\frac{1}{8}$ teaspoon Cadmium Yellow Deep

Colour mix for purple tones

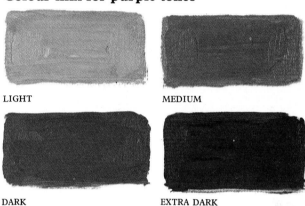

LIGHT MEDIUM

DARK EXTRA DARK

MEDIUM TONE
1 teaspoon White
$\frac{1}{2}$ teaspoon purple
smidge Yellow Ochre

Mix the paint and separate it into three parts, one small ($\frac{1}{2}$ teaspoon) and two equal parts.

1. LIGHT TONE
Use the first part ($\frac{1}{2}$ teaspoon).
Add: $\frac{1}{2}$ teaspoon White
 smidge Naples Yellow

2. MEDIUM TONE
Use the second part. Leave it as it is.

3. DARK TONE
Use the third part.
Add: $\frac{1}{4}$ teaspoon purple
 smidge Yellow Ochre
 smidge Cadmium Orange

4. EXTRA DARK TONE
When this is required, to $\frac{1}{2}$ teaspoon dark tone.
Add: $\frac{1}{4}$ teaspoon purple
 smidge Cadmium Orange

Colour mix for green tones

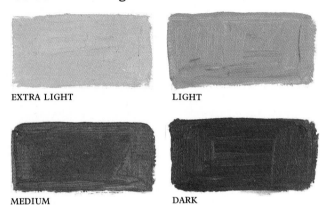

EXTRA LIGHT LIGHT

MEDIUM DARK

MEDIUM TONE
½ teaspoon Yellow Ochre
1 tablespoon mixed green
smidge Vermilion

Mix the paint and separate it into three parts, one small (½ teaspoon) and two equal parts.

1. LIGHT TONE
Use the first part (½ teaspoon).
Add: 1 teaspoon White
 ¾ teaspoon Lemon Yellow

2. MEDIUM TONE
Use the second part. Leave it as it is.

3. DARK TONE
Use the third part.
Add: ¼ teaspoon purple
 ¼ teaspoon mixed green
If the dark tone turns muddy from adding too much purple, add a little extra mixed green.

4. EXTRA LIGHT TONE
When this is required, to ½ teaspoon light tone.
Add: ½ teaspoon White
 ¼ teaspoon Lemon Yellow

● To create the effect of distance in trees in a painting, take ½ teaspoon each of the light and medium tones of the above green tones and add to each tone ½ teaspoon of light sky tone (see colour mix on page 22).

Colour mix for black tones

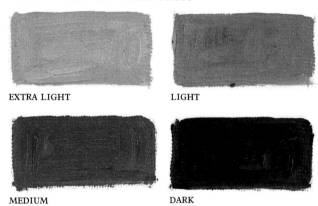

EXTRA LIGHT LIGHT

MEDIUM DARK

DARK TONE
½ teaspoon Burnt Umber
½ teaspoon French Ultramarine

Mix the paint and separate it into three parts, one small (½ teaspoon) and two equal parts.

1. LIGHT TONE
Use the small part (¼ teaspoon).
Add: ½ teaspoon White
 tiny smidge Naples Yellow
 tiny smidge Cadmium Orange

2. MEDIUM TONE
Use the second part.
Add: ¼ teaspoon White
 smidge Cadmium Orange

3. DARK TONE
Use the third part. Leave it as it is.

4. EXTRA LIGHT TONE
When this is required, to ½ teaspoon light tone
Add: ½ teaspoon White
 smidge Cadmium Orange

Colour mix for white tones

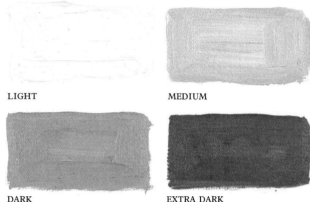

LIGHT

MEDIUM

DARK

EXTRA DARK

LIGHT TONE
1¾ tablespoons White
smidge Naples Yellow (easy does it)

Mix the paint and separate it into three parts.

1. LIGHT TONE
Use the first part. Leave it as it is.

2. MEDIUM TONE
Use the second part.
Add : ⅛ teaspoon Burnt Umber
 smidge aqua
The colour will look beige – if it is too dark, add more white.

3. DARK TONE
Use the third part.
Add : ⅛ teaspoon Burnt Umber
 ⅛ teaspoon aqua
 smidge Cadmium Orange

4. EXTRA DARK TONE
When this is required, to ½ teaspoon dark tone
Add : ⅛ teaspoon Burnt Umber
 smidge Cadmium Orange

GREYED BACKGROUND COLOURS

1. These colours are especially useful in still life as they will not have and should not have the same intensity, vibrance and importance as the subject matter.
2. They can also be used in other objects in painting and are especially important in buildings.
3. If you have a larger canvas and need more background colour, mix another half batch.
4. These colours will look strange on the palette but not on the canvas when the subject is painted in.

Colour mix for greyed tones of burnt orange

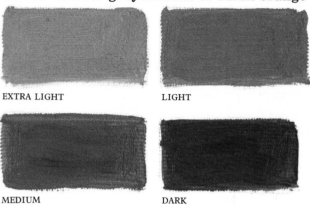

EXTRA LIGHT

LIGHT

MEDIUM

DARK

MEDIUM TONE
1¼ teaspoons Cadmium Orange
¼ teaspoon Alizarin Crimson
smidge purple
smidge mixed green (easy does it)

Mix the paint and separate it into three parts, one small (½ teaspoon) and two equal parts.

1. LIGHT TONE
Use the first part (½ teaspoon).
Add : ½ teaspoon White
 ¼ teaspoon Cadmium Yellow Deep

2. MEDIUM TONE
Use the second part. Leave it as it is.

3. DARK TONE
Use the third part.
Add : ½ teaspoon Alizarin Crimson
 ¼ teaspoon purple
 smidge mixed green

4. EXTRA LIGHT TONE
When this is required, to ½ teaspoon light tone
Add : ½ teaspoon White
 smidge of Cadmium Yellow Deep

Colour mix for greyed tones of yellow ochre

EXTRA LIGHT

LIGHT

MEDIUM

DARK

MEDIUM TONE

1 tablespoon Yellow Ochre
⅛ teaspoon purple

Mix the paint and separate it into three parts, one small (½ teaspoon) and two equal parts.

1. LIGHT TONE
Use the first part (½ teaspoon).
Add: ½ teaspoon White
¼ teaspoon Cadmium Yellow Deep

2. MEDIUM TONE
Use the second part. Leave it as it is.

3. DARK TONE
Use the third part.
Add: ½ teaspoon purple
smidge mixed green

4. EXTRA LIGHT TONE
When this is required, to ¼ teaspoon light tone
Add: ½ teaspoon White
smidge Cadmium Yellow Deep

Colour mix for greyed tones of light green

EXTRA LIGHT

LIGHT

MEDIUM

DARK

MEDIUM TONE

1 tablespoon White
1 teaspoon Yellow Ochre
½ teaspoon mixed green
smidge purple
smidge Vermilion

Mix the paint and separate it into three parts, one small (½ teaspoon) and two equal parts.

1. LIGHT TONE
Use the first part (½ teaspoon).
Add: ¾ teaspoon White
smidge Yellow Ochre

2. MEDIUM TONE
Use the second part. Leave it as it is.

3. DARK TONE
Use the third part.
Add: ¼ teaspoon purple
smidge mixed green

4. EXTRA LIGHT TONE
When this is required, to ¼ teaspoon light tone
Add: ½ teaspoon White

Colour mix for greyed tones of dark green

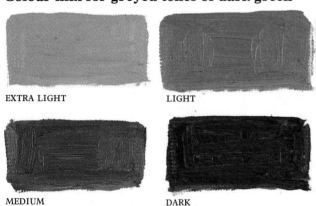

EXTRA LIGHT LIGHT

MEDIUM DARK

MEDIUM TONE
1 tablespoon Yellow Ochre
$\frac{1}{4}$ teaspoon mixed green
$\frac{1}{4}$ teaspoon Vermilion
$\frac{1}{4}$ teaspoon purple

Mix the paint and separate it into three parts, one small ($\frac{1}{2}$ teaspoon) and two equal parts.

1. LIGHT TONE
Use the first part ($\frac{1}{2}$ teaspoon).
Add: $\frac{1}{2}$ teaspoon White
 smidge Yellow Ochre

2. MEDIUM TONE
Use the second part. Leave it as it is.

3. DARK TONE
Use the third part.
Add: $\frac{1}{2}$ teaspoon purple
 $\frac{1}{8}$ teaspoon Viridian
 smidge Yellow Ochre

4. EXTRA LIGHT TONE
When this is required, to $\frac{1}{4}$ teaspoon light tone
Add: $\frac{1}{2}$ teaspoon White
 smidge Yellow Ochre

ALTERNATIVE BACKGROUND COLOURS

These colours are used straight from the palette.

VERMILION PURPLE

ALIZARIN CRIMSON

Paint the background with alternate criss-cross strokes of purple and Alizarin Crimson using the flat of the offset knife. Paint a few criss-cross strokes of Vermilion here and there over the first two background colours – not too much.

33

MIXTURES FOR COLOUR TINTS

1. These colour tints are invaluable in painting where pastel shades are required.

2. When mixing colours for tints, easy does it as you can always add more.

3. Remember to keep the knife clean when going from one colour to another.

Colour mix for yellow tint

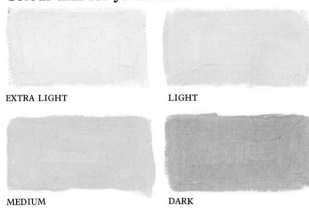

EXTRA LIGHT LIGHT

MEDIUM DARK

MEDIUM TONE

$1\frac{1}{4}$ teaspoons White
$\frac{1}{2}$ teaspoon Cadmium Yellow Deep
$\frac{1}{8}$ teaspoon Lemon Yellow

Mix the paint and separate it into three parts, one small ($\frac{1}{2}$ teaspoon) and two equal parts.

1. LIGHT TONE
Use the first part ($\frac{1}{2}$ teaspoon).
Add : 1 teaspoon White
 $\frac{1}{8}$ teaspoon Lemon Yellow

2. MEDIUM TONE
Use the second part. Leave it as it is.

3. DARK TONE
Use the third part.
Add : $\frac{1}{2}$ teaspoon Cadmium Yellow Deep
 $\frac{1}{2}$ teaspoon Yellow Ochre
 $\frac{1}{8}$ teaspoon Cadmium Orange

4. EXTRA LIGHT TONE
When this is required, to $\frac{1}{4}$ teaspoon light tone
Add : $\frac{1}{2}$ teaspoon White

Colour mix for orange tint

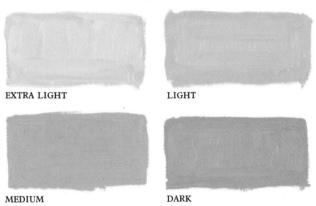

EXTRA LIGHT LIGHT

MEDIUM DARK

MEDIUM TONE

1 teaspoon White
$\frac{1}{2}$ teaspoon Cadmium Orange
$\frac{1}{8}$ teaspoon Cadmium Yellow Deep

Mix the paint and separate it into three parts, one small ($\frac{1}{2}$ teaspoon) and two equal parts.

1. LIGHT TONE
Use the first part ($\frac{1}{2}$ teaspoon).
Add : $\frac{3}{4}$ teaspoon White
 smidge Cadmium Yellow Deep

2. MEDIUM TONE
Use the second part. Leave it as it is.

3. DARK TONE
Use the third part.
Add : $\frac{3}{4}$ teaspoon Cadmium Orange
 smidge Vermilion

4. EXTRA LIGHT TONE
When this is required, to $\frac{1}{4}$ teaspoon light tone
Add : $\frac{1}{2}$ teaspoon White

Colour mix for red tint

EXTRA LIGHT

LIGHT

MEDIUM DARK

MEDIUM TONE
$1\frac{1}{4}$ teaspoons White
$\frac{1}{2}$ teaspoon Vermilion
$\frac{1}{8}$ teaspoon Cadmium Orange

Mix the paint and separate it into three parts, one small ($\frac{1}{2}$ teaspoon) and two equal parts.

I. LIGHT TONE
Use the first part ($\frac{1}{2}$ teaspoon).
Add: 1 teaspoon White
 smidge Naples Yellow
 smidge Cadmium Orange

2. MEDIUM TONE
Use the second part. Leave it as it is.

3. DARK TONE
Use the third part.
Add: $\frac{3}{4}$ teaspoon Vermilion
 smidge Cadmium Orange

4. EXTRA LIGHT TONE
When this is required, to $\frac{1}{4}$ teaspoon light tone
Add: $\frac{1}{2}$ teaspoon white

Colour mix for dark red tint

EXTRA LIGHT

LIGHT

MEDIUM DARK

MEDIUM TONE
$1\frac{1}{4}$ teaspoons White
$\frac{1}{2}$ teaspoon Alizarin Crimson

Mix the paint and separate it into three parts, one small ($\frac{1}{2}$ teaspoon) and two equal parts.

I. LIGHT TONE
Use the first part ($\frac{1}{2}$ teaspoon).
Add: 1 teaspoon White
 smidge Naples Yellow

2. MEDIUM TONE
Use the second part. Leave it as it is.

3. DARK TONE
Use the third part.
Add: $\frac{3}{4}$ teaspoon Alizarin Crimson
 smidge Cadmium Orange

4. EXTRA LIGHT TONE
Add: $\frac{1}{2}$ teaspoon White

Colour mix for lavender purple tint

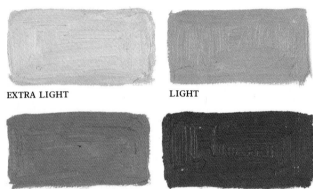

EXTRA LIGHT LIGHT

MEDIUM DARK

MEDIUM TONE
$1\frac{1}{2}$ teaspoons White
$\frac{1}{2}$ teaspoon purple
$\frac{1}{4}$ teaspoon Alizarin Crimson

Mix the paint and separate it into three parts, one small ($\frac{1}{2}$ teaspoon) and two equal parts.

1. LIGHT TONE
Use the first part ($\frac{1}{2}$ teaspoon).
Add: 1 teaspoon White
 smidge Alizarin Crimson

2. MEDIUM TONE
Use the second part. Leave it as it is.

3. DARK TONE
Use the third part.
Add: $\frac{1}{2}$ teaspoon purple
 $\frac{1}{8}$ teaspoon Alizarin Crimson

4. EXTRA LIGHT TONE
When this is required, to $\frac{1}{4}$ teaspoon light tone
Add: $\frac{1}{2}$ teaspoon White

Colour mix for blue purple tint

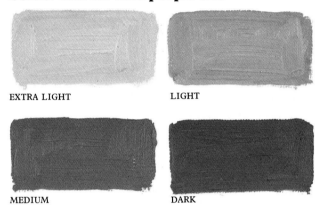

EXTRA LIGHT LIGHT

MEDIUM DARK

MEDIUM TONE
$1\frac{1}{2}$ teaspoons White
$\frac{1}{2}$ teaspoon purple

Mix the paint and separate it into three parts, one small ($\frac{1}{2}$ teaspoon) and two equal parts.

1. LIGHT TONE
Use the first part ($\frac{1}{2}$ teaspoon).
Add: 1 teaspoon White
 smidge Naples Yellow

2. MEDIUM TONE
Use the second part. Leave it as it is.

3. DARK TONE
Use the third part.
Add: $\frac{3}{4}$ teaspoon purple
 smidge French Ultramarine

4. EXTRA LIGHT TONE
When this is required, to $\frac{1}{4}$ teaspoon light tone
Add: $\frac{1}{2}$ teaspoon White

Colour mix for blue tint

EXTRA LIGHT

LIGHT

MEDIUM

DARK

MEDIUM TONE
1¼ teaspoons White
¼ teaspoon aqua
⅛ teaspoon French Ultramarine

Mix the paint and separate it into three parts, one small (½ teaspoon) and two equal parts.

1. LIGHT TONE
Use the first part (½ teaspoon).
Add: 1 teaspoon White
 smidge aqua

2. MEDIUM TONE
Use the second part for the medium tone. Leave it as it is.

3. DARK TONE
Use the third part.
Add: ¼ teaspoon French Ultramarine
 ⅛ teaspoon aqua

4. EXTRA LIGHT TONE
When this is required, to ¼ teaspoon light tone
Add: ½ teaspoon White

Colour mix for green tint

EXTRA LIGHT

LIGHT

MEDIUM

DARK

MEDIUM TONE
1 teaspoon White
½ teaspoon Yellow Ochre
½ teaspoon mixed green
smidge Cadmium Yellow Deep

Mix the paint and separate it into three parts, one small (½ teaspoon) and two equal parts.

1. LIGHT TONE
Use the first part (½ teaspoon).
Add: 1 teaspoon White
 ¼ teaspoon Lemon Yellow

2. MEDIUM TONE
Use the second part. Leave it as it is.

3. DARK TONE
Use the third part.
Add: ¼ teaspoon mixed green
 smidge purple
 smidge Cadmium Yellow Deep

4. EXTRA LIGHT TONE
When this is required, to ¼ teaspoon light tone
Add: ¾ teaspoon White

COLOUR MIXES FOR PORTRAIT PAINTING

Flesh tones are subtle and delicate. Use the darker colours sparingly. You can always add more as you go.

Colour mix for flesh tones

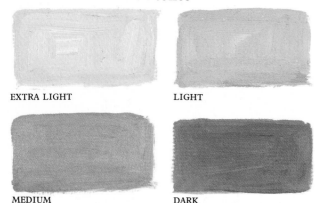

EXTRA LIGHT LIGHT

MEDIUM DARK

MEDIUM TONE
1 teaspoon White
⅛ teaspoon Yellow Ochre
smidge Cadmium Orange
smidge Burnt Umber (easy does it)

Mix the paint and separate it into three parts, one small (½ teaspoon) and two equal parts.

1. LIGHT TONE
Use the first part (½ teaspoon).
Add: ¼ teaspoon White
 smidge Naples Yellow
 smidge Cadmium Orange

2. MEDIUM TONE
Use the second part. Leave it as it is.

3. DARK TONE
Use the third part.
Add: smidge Naples Yellow
 smidge Cadmium Orange
 smidge Burnt Umber (easy does it)
If necessary add more smidges in dark tones. There must be distinct tonal values of light, medium and dark.

4. EXTRA LIGHT TONE (use for highlights)
When this is required, to ⅛ teaspoon light tone
Add: ⅛ teaspoon White
 smidge Naples Yellow

For painting lips

Remove a bit of the light flesh tone, and keep to one side for using on lips.

1. For lip colour, add a smidge of Vermilion to the light flesh tone.

2. For darker lip tone, for shading, add a smidge of Alizarin Crimson to the light flesh tone.

For painting eyes

1. Dark eyes
Use the dark tone of dark hair for the iris in the centre of the eye, the light tone for the pupil while for the whites of the eyes, use an off-white. To obtain an off-white colour, use the light tone of White plus a tiny smidge of French Ultramarine from the palette. This off-white colour can also be used for the highlight in the centre of the eye.

2. Blue eyes
Use the medium and light tones of blue. The colour mix is on page 26. Use the medium tone for the iris and the light tone for the pupil. Use an off-white for the whites of the eyes. To obtain an off-white colour, use the light tone of White plus a tiny smidge of French Ultramarine from the palette. This off-white colour can also be used for the highlight in the centre of the eye.

For painting hair

The following colour mixes can be used for painting different colours of hair.

1. Light hair

Refer to page 24 for the colour mix of earth tones.

LIGHT *for highlights*

MEDIUM

DARK

EXTRA DARK

Naples Yellow can be used on highlights.

2. Dark hair

Refer to page 25 for the colour mix of tree tones.

LIGHT *for highlights*

MEDIUM

DARK

EXTRA DARK

3. Red hair

Refer to page 31 for the colour mix of greyed background burnt orange.

EXTRA LIGHT *for highlights*

LIGHT

MEDIUM

DARK

4. Grey hair

Refer to page 31 for the colour mix of tones of white.

LIGHT *for highlights*

MEDIUM

DARK

EXTRA DARK

5. White hair

Use the light, medium and dark tones of white only,

LIGHT

MEDIUM

DARK

Paintings to practise

Use a canvas 14 by 18 inches (36 by 46 cm).
Study the drawings on pages 40, 42 and 43, and also the finished painting. Then proceed as follows:

1. Cover the canvas with an umber wash. To make the umber wash, squeeze out ½ teaspoonful of Burnt Umber. Dip the large, flat, bristle brush into the turpentine – make sure that it is not dripping too much – and then dip the brush into the Burnt Umber on the palette, pulling some aside to make a light, rather thin wash. Cover the canvas with the umber wash, taking care not to make the canvas too dark or runny. Wipe off any excess moisture with toilet tissue but leave the canvas damp.

2. To divide the canvas up into sections, use the medium, round brush and umber wash. Use slightly more Burnt Umber than turpentine in order to achieve a darker colour wash than before. The canvas is to be used horizontally in this painting, so draw three horizontal lines equally spaced and five vertical lines, also equally spaced. A useful tip is to divide the canvas into quarters first. The sections do not have to be measured off exactly. See the drawing below.

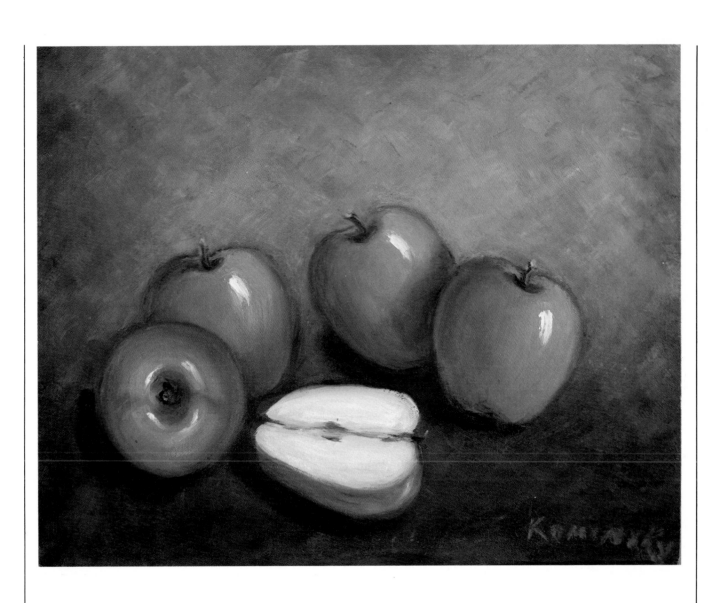

The finished painting

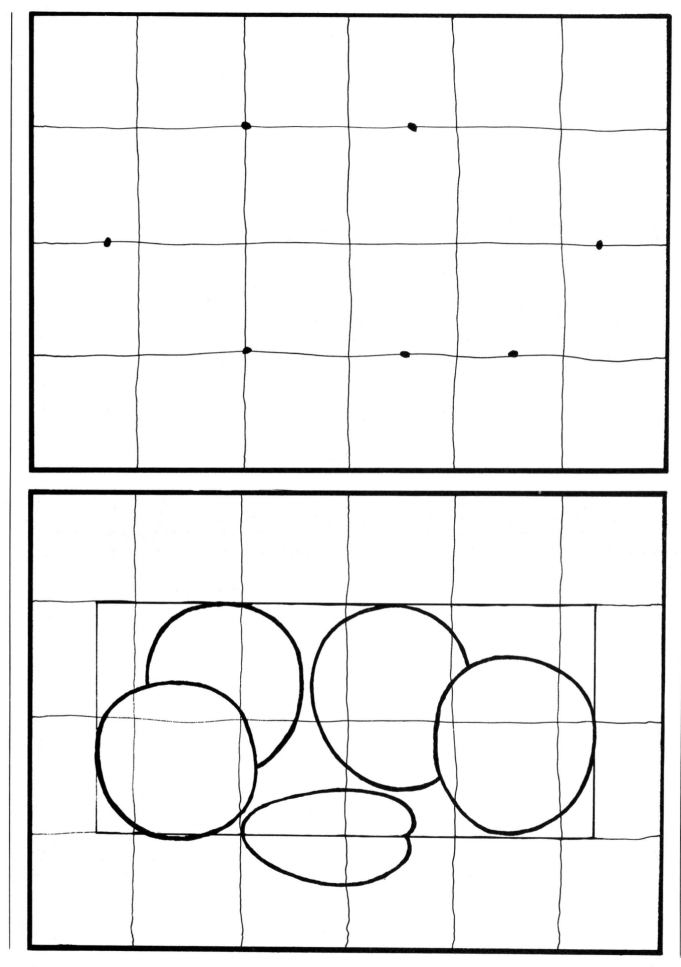

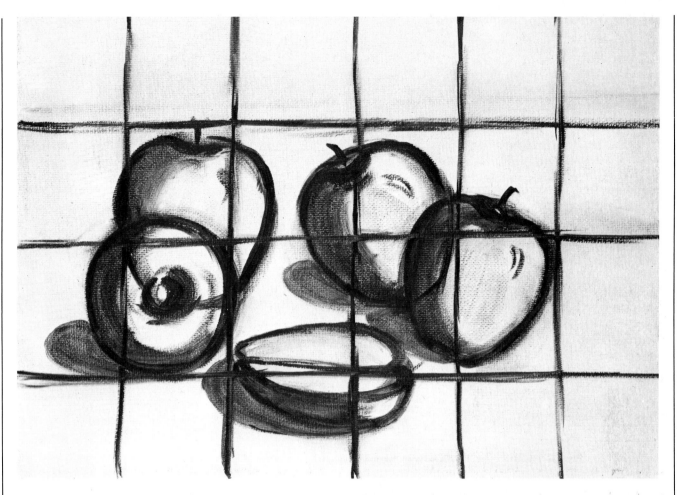

3. To help with placing work on the canvas, use the squares as guidelines and draw in the dots as shown in the drawing opposite above, using the darker umber wash.

4. Draw in circles for the apples and a half circle for the cut apple, using the drawing opposite below and the finished painting as a guideline.

5. In this painting, the light is coming from the right. Lightly put in the shadows as in the drawing above.

6. The colour mixes to use are shown in the drawing below. Remember to use round strokes when painting the apples to keep the form. The colour mix of greyed dark green is used for the background. Use purple for the tips of the stems.

7. Refer to the index at the end of the book for the colour mixes needed.

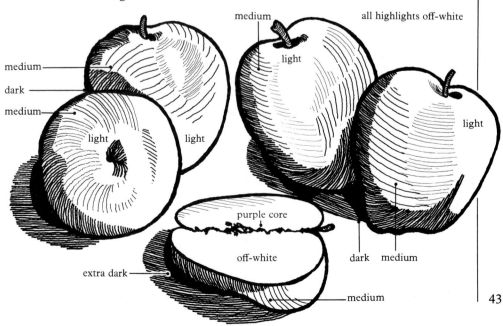

43

PEARS

Use a canvas 9 by 12 inches (23 by 30 cm). Study the drawings on this page and also the finished painting. Then proceed as follows:

1. Cover the canvas with an umber wash. To make the umber wash, squeeze out $\frac{1}{2}$ teaspoonful of Burnt Umber. Dip the large, flat, bristle brush into the turpentine – make sure that it's not dripping too much – and then dip the brush into the Burnt Umber on the palette, pulling some aside to make a light, rather thin wash. Cover the canvas with the wash, taking care not to make it too dark or runny. Wipe off any excess moisture with toilet tissue but leave the canvas damp.

2. To divide the canvas up into sections, use the medium, round brush and umber wash. This time, use slightly more Burnt Umber than turpentine in order to achieve a darker colour wash than before. The canvas is to be used horizontally in this painting, so draw three horizontal lines equally spaced and five vertical lines, also equally spaced. A useful tip is to divide the canvas into quarters first. The sections do not have to be measured off exactly. See the drawing below.

3. To help with placing work on the canvas, use the squares as guidelines and draw in the dots as shown in the drawing below.

4. Study the drawing below and note that the light is coming from the right, therefore the shadows are on the left. Refer to the index for the colour mixes required.

5. Use the greyed dark green colour mix for the background. Paint the background first before you start on the fruit.

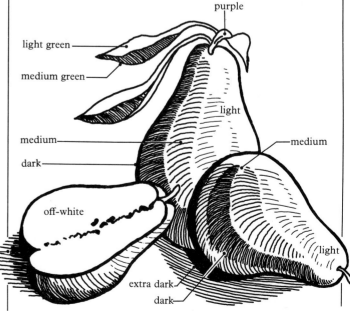

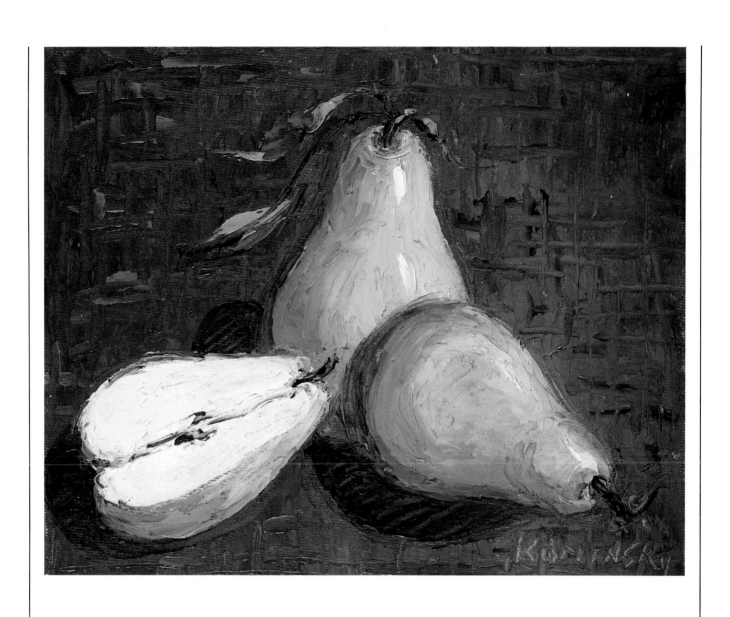

The finished painting

Use a canvas 9 by 12 inches (23 by 30 cm).
Study the drawings on this page and also the finished painting. Then proceed as follows:

1. Cover the canvas with an umber wash. To make the umber wash, squeeze out ½ teaspoonful of Burnt Umber. Dip the large, flat, bristle brush into the turpentine – make sure that it's not dripping too much – and then into the Burnt Umber on the palette, pulling some aside with the brush to make a light, rather thin wash. Cover the canvas with the wash, taking care not to make it too dark or runny. Wipe off any excess moisture with toilet tissue but leave the canvas damp.

2. To divide the canvas up into sections, use the medium, round brush and umber wash. This time, use slightly more Burnt Umber than turpentine in order to achieve a darker colour wash than before. The canvas is to be used horizontally in this painting, so draw three horizontal lines equally spaced across the canvas and five vertical lines, also equally spaced. A useful tip is to divide the canvas into quarters first. The sections do not have to be measured off exactly. See the drawing below.

3. To help with placing work on the canvas, use the squares as guidelines and draw in the dots as shown in the drawing below.

4. Study the drawing below and note that the light is coming from the right, therefore the shadows are on the left. Refer to the index at the end of the book for the colour mixes required.

5. Use the greyed dark green colour mix for the background. Paint the background before you start on the fruit.

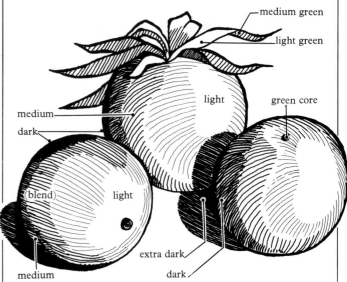

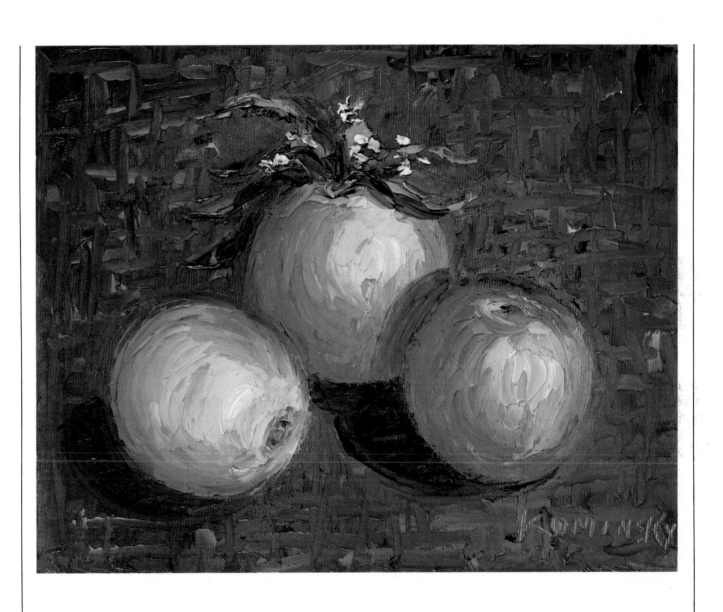

The finished painting

SPRING BOUQUET

Still life is better for a beginner: it is less demanding and much more rewarding. I have chosen this wild spring bouquet for you to practise mixing the colour tints. If you have any mixed colours left over you can keep the paint (see page 55) to use on other small flower paintings. Look at the drawing and the finished painting carefully.

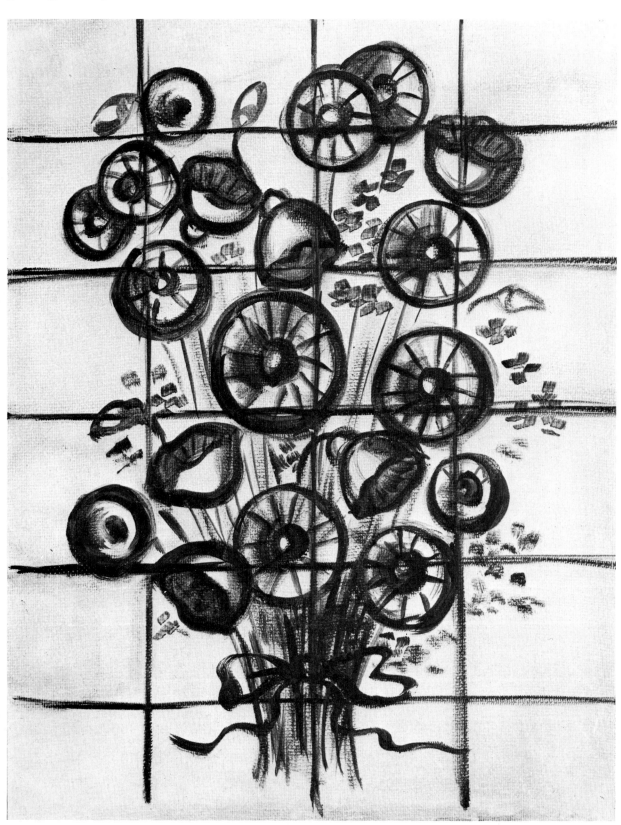

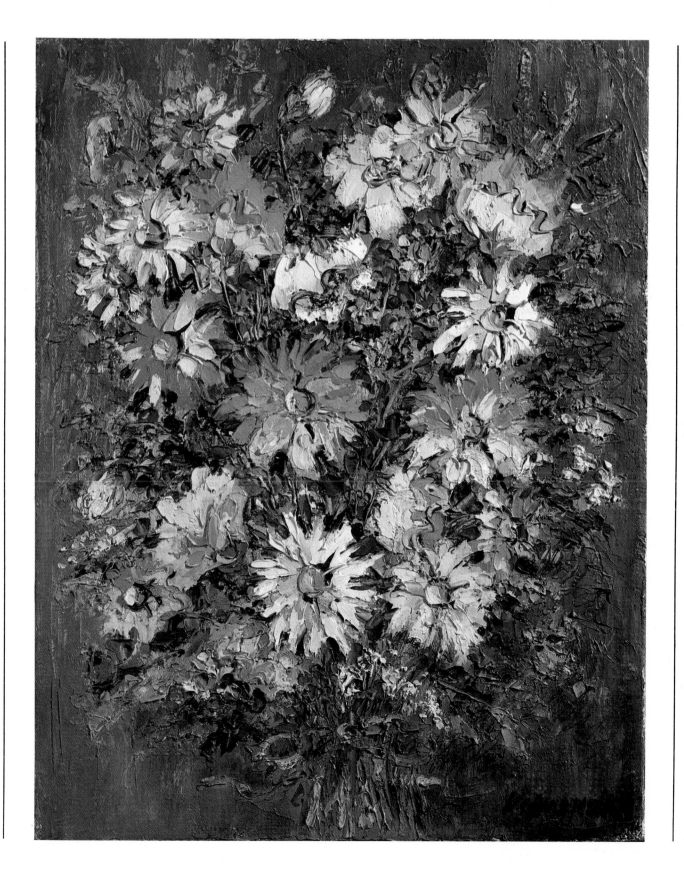

The drawing

1. Use a canvas 14 by 18 inches (36 by 46 cm). You may use a smaller or larger canvas as long as it has the same proportion to place the subject correctly. The smaller size will, of course, save on the amount of paint required.

2. Arrange the palette according to the instructions on page 16.

3. Using the large, flat, hog bristle brush, stain the canvas with a light wash of Burnt Umber as described on page 13. Wipe off the surplus wash with toilet tissue but still leave the canvas damp.

4. With the medium, round brush and dark umber wash, draw in the grid lines and the simple drawing.

5. In this picture, the light is coming from the left – note the highlights on the petals – so lightly shade the flowers where indicated.

6. Clean the brushes you have used so far in turpentine, using some toilet tissue.

The painting

The background is painted in first.

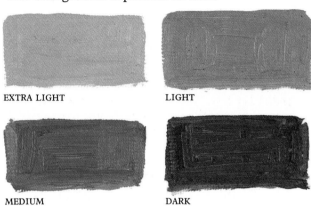

EXTRA LIGHT LIGHT

MEDIUM DARK

1. Refer to page 33 for the colour mixes for greyed dark green and mix the paint according to the instructions.

2. Using the offset knife, paint the dark greyed green tone on the right of the canvas, then the medium tone, and the light and extra light tone on the left. Remember to blend the tones slightly into one another for depth. Clean the knife.

Flowers

1. Because the painting is a multi-coloured floral, it is logical when you mix one colour to paint all the flowers in that one colour at the same time before going on to a second colour. Study the painting carefully.

2. The flower drawings I have drawn for you here are precise so that you can understand the structure and colour area. You will notice that the finished painting is much more impressionistic. Try for a looser painting yourself. It is more important to retain tonal values than form. Practise painting a few flowers before going to canvas.

Orange flowers

Use the colour mix for the orange tint on page 34.

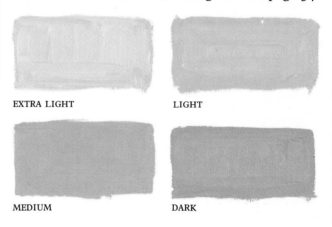

EXTRA LIGHT LIGHT

MEDIUM DARK

1. Mix the paint according to the instructions.

2. Paint all the orange flowers, beginning with the dark tone, then continuing with the medium, light and extra light tones. Keep any leftover paint. Do not paint any of the tones over one another. This will muddy and destroy the tonal values. Only blend the tones where they meet. Keep the strokes free and easy.

3. Paint the centres of the flowers last. All the flowers have the same colour centre. Use Yellow Ochre straight from the palette. Paint the centres with round strokes. Finally, apply a highlight of Naples Yellow from the palette to the centre.

4. Clean the knife before painting another colour.

Pink flowers

Use the colour mix for the red tint on page 35.

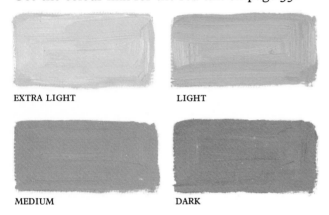

EXTRA LIGHT LIGHT

MEDIUM DARK

1. Mix the paint according to the instructions.

2. Paint all the pink flowers starting with the dark tone, then continue with the medium, light and extra light tones. Keep any leftover paint. Do not paint any of the tones over one another. This will muddy and destroy the tonal values. Only blend the tones where they meet.

3. Paint the centres of the flowers last, using Yellow Ochre straight from the palette. Paint the centres with round strokes. Finally, apply a highlight of Naples Yellow from the palette to the centre.

4. Clean the knife before painting another colour.

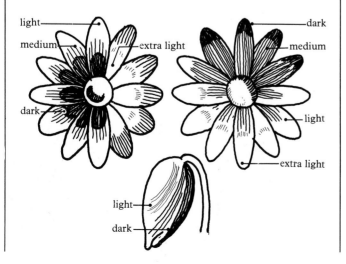

Yellow flowers

Use the colour mix for the yellow tint on page 34.

EXTRA LIGHT LIGHT

MEDIUM DARK

1. Mix the paint according to the instructions.

2. Paint all the yellow flowers, starting with the dark tone, then continue with the medium, light and extra light tones. Keep any leftover paint. Do not paint any of the tones over one another. This will muddy and destroy the tonal values. Only blend the tones where they meet at the edges.

3. Put a wavy line of Vermilion between the light and medium colours (see drawing below).

4. Paint the centres of the flowers last, using Yellow Ochre straight from the palette. Paint the centres with round strokes. Finally, apply a highlight of Naples Yellow from the palette to the centre.

5. Clean the knife before painting another colour.

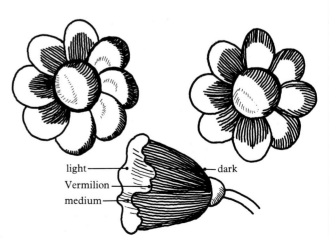

Purple flowers
Use the mix for the lavender purple tint on page 36.

EXTRA LIGHT LIGHT

MEDIUM DARK

1. Mix the paint according to the instructions.

2. Paint all the purple flowers, starting with the dark tone, and continuing with the medium, light and extra light tones. Remember to keep the tonal values. Keep any leftover paint.

3. Referring to the drawings, paint the centre of one flower as usual, using Yellow Ochre straight from the palette. For the second and third flowers take some purple straight from the palette and paint a wavy line between the dark and medium areas on the flowers.

4. Paint the centres of the rest of the purple flowers as usual, using Yellow Ochre straight from the palette. Paint the centres with round strokes. Finally, apply a highlight of Naples Yellow from the palette to the centre of the flowers.

5. Clean the knife before painting another colour.

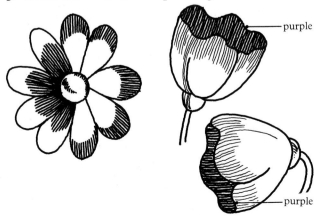

White flowers
Use the colour mix for tones of white on page 31.

LIGHT MEDIUM

DARK

1. Mix the paint according to the instructions, remembering not to make up the extra dark tone of white.

2. Paint the small flowers in two tones only, the light and medium tones. Paint the yellow centres of the flowers, using Yellow Ochre straight from the palette. Paint the buds in the same tones, remembering to keep them looking delicate.

3. Paint all the other white flowers with the dark, medium and light tones. Keep any leftover paint.

4. Paint the centres of the rest of the white flowers last, using Yellow Ochre straight from the palette. Paint the centres with round strokes. Finally, apply a highlight of Naples Yellow from the palette to the centre of the flowers.

5. Clean the knife before painting another colour.

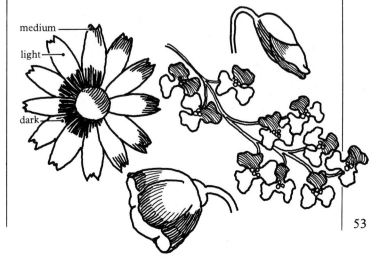

Blue flowers

Use the colour mix for the blue tint on page 37.

EXTRA LIGHT LIGHT

MEDIUM DARK

1. Mix the paint according to the instructions.

2. Paint the large blue flowers, using the dark, medium, light and extra light tones.

3. Paint the small blue flowers in dark and extra light tones only. Keep the flowers delicate.

4. Paint the centres of the flowers last, using Yellow Ochre straight from the palette. Apply the paint to the centres with round strokes. Finally, apply a highlight of Naples Yellow from the palette to the centre.

5. Clean the knife before painting another colour.

6. The ribbon will be painted in the same blue tones later on, so keep any leftover paint carefully.

Leaves and stems

Use the colour mix of tones of green on page 30.

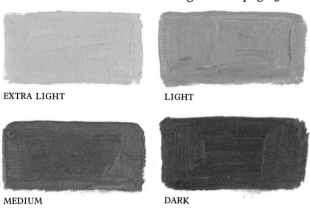

EXTRA LIGHT LIGHT

MEDIUM DARK

1. Study the drawing and painting on pages 48 and 49. Remember to paint only impressions of leaves, using the different tonal values of green.

2. Mix the paint according to the instructions.

3. Paint the stems at the bottom with dark and medium tones on the right hand side of the canvas and with light and extra light tones on the left hand side of the canvas.

4. On the left hand side of the painting, between the flowers, and on the background, paint in impressions of light and extra light tones of green leaves – don't paint in too many.

5. Paint dark and medium tones of green leaves on the righthand side and the dark side and in between the flowers – don't paint in too many. Keep the leaves indistinct.

6. Clean the knife before painting in the ribbon.

Ribbon

1. Finally, paint the ribbon on the stems, using the dark and light and extra light blue tones – keep the ribbon delicate and flowing.

2. Put any leftover piles of paint neatly onto a tin foil dish, cover with cling film and put the dish in the freezer for use on smaller canvases.

If you have leftover paint, you can have fun mixing and matching the paints for other floral paintings. Use small 9 by 12 inch (23 by 30 cm) canvases. Here are some suggestions for colour schemes to use. Try these combinations or make up your own.

1.
Background: tones of yellow	page 27
Flowers: tones of white	page 31

2.
Background: tones of light greyed green	page 32
Flowers: orange tint	page 34
Daisies: yellow tint	page 34

3.
Background: dark greyed green	page 33
Flowers: red tint	page 35
Small flowers: tones of white	page 31

4.
Background: greyed yellow ochre	page 32
Flowers: blue tint	page 37
Flowers: yellow tint	page 34

5.
Background: light greyed green	page 32
Flowers: blue purple tint	page 36
Flowers: yellow tint	page 34

Leaves and stems of all flowers: tones of green	page 30

LANDSCAPE – REFLECTIONS

This landscape exercise is primarily for you to learn how to refer to the index of colour formulas and how to mix colour and to paint on your own. Don't panic – you will be very pleased and surprised at your first efforts. In this painting you will be learning how to paint water and snow-capped mountains. Look at the drawing and finished painting carefully.

The drawing

1. Use a canvas 14 by 18 inches (36 by 46 cm).

2. Arrange the palette according to the instructions on page 16.

3. Using the large, flat hog bristle brush, stain the canvas with a light wash of Burnt Umber as described on page 13. Wipe off any surplus wash with toilet tissue but leave the canvas damp.

4. With the medium round brush and dark umber wash, draw in the grid lines (see page 13) and simple drawing (see opposite).

5. In this painting the light is coming from the right. Note the light on the righthand side of the mountains, trees and water.

The painting

Refer to Landscape in the index on page 63. This will give you the colour mixes for the painting. Mix the paints according to the instructions, using a straight knife.

The sky

This is always painted in first. Use the offset knife for painting. Paint the extra light tone along the top of the mountains, continuing with the other tones. Remember to blend the paint where the tones meet.

The mountains

Paint the mountains before adding the snow. Keep the mountains darker at the base. Watch the shape of the strokes. Use the drawing below as a guideline.

How to create the effect of mountains using the flat of the offset knife

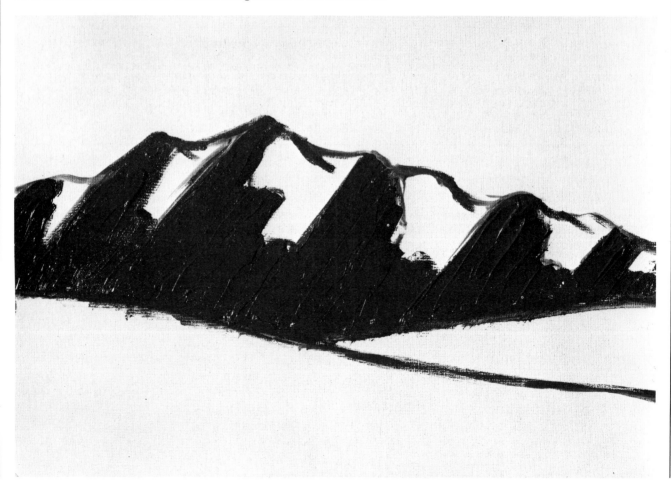

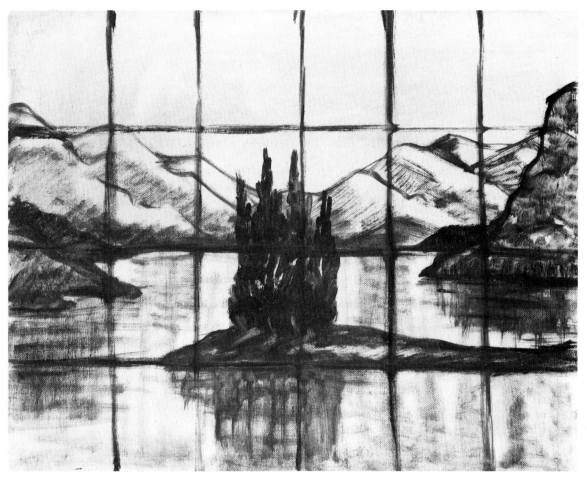

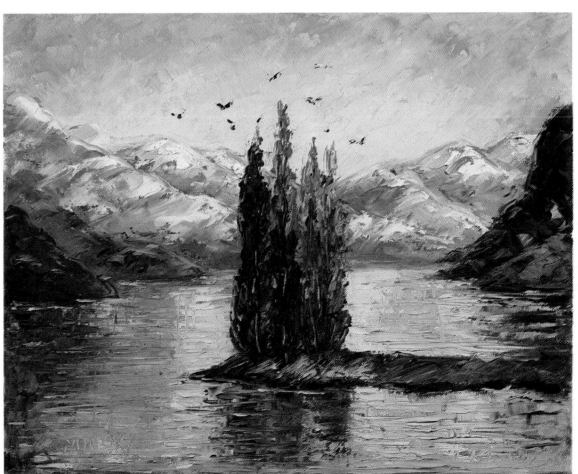

Snow

Mix the light and medium tones of white only. Paint snow only where indicated on the finished painting. Not too much!

The hills

Add purple to the dark green tone of the hills where indicated. Paint some green tones for the strip of land running from the trees.

The lake

Paint all the water tones separately and only blend them where they meet for sharp reflections. Paint green tones in the water for reflection of the hills and trees. Run strokes through the water from left to right with the clean tip of the knife. Keep on cleaning the knife as you do this. This will give the water a 'wet' look.

The trees

Keep them slender and tall, and uneven in height. Paint purple at the base of the trees and use it for the shadows of the trees on the ground.

Now that you have finished this painting all on your own, you have probably been encouraged to try painting your own subjects. Keep on painting!

LANDSCAPE – FIELD OF POPPIES

How to paint from a picture postcard or a photograph using the colour mixes in the book.

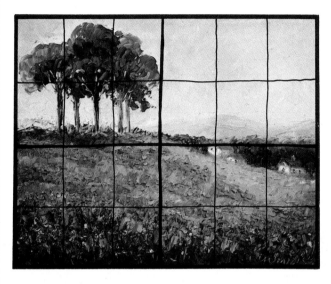

1. The above postcard is a simple composition. Later on you can copy from your own postcards.

2. Cover the postcard with cling film if you do not want to mark it. Draw grids as illustrated with a round brush and Burnt Umber wash. To make the umber wash, squeeze out ½ teaspoonful of Burnt Umber. Dip the brush into the turpentine – it should not be dripping – and then into the Burnt Umber on the palette, pulling some aside to make a light, rather thin wash. To draw the grids on a horizontal photograph, draw three horizontal lines equally spaced and five vertical lines, also equally spaced. A useful tip is to divide the photograph up into quarters first, then divide each section as indicated. The sections do not have to be measured and exact.

3. Using the grids on the photograph as a guide, it is now easy to proceed with the real canvas.

4. Use a 14 by 18 inch (36 by 46 cm) canvas which has been stained with an umber wash as described on page 13.

5. Using the same umber wash as that used on the photograph – make sure that this umber wash is slightly darker than that used for staining the canvas by using more Burnt Umber than turpentine – divide the canvas up into sections using the same method.

6. Decide where the light is coming from and shade in the drawing as indicated. In this photograph the light is coming from the right. Notice the shadows under the trees and in the foreground.

The sky

This is always painted in first. Use the colour mix for sky tones on page 22.

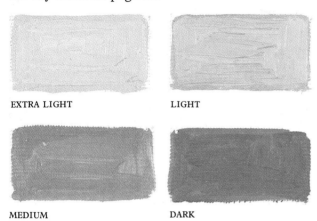

EXTRA LIGHT LIGHT

MEDIUM DARK

1. Mix the paint according to the instructions.

2. With the offset knife, paint the extra light sky tone along the top of the hills in the distance. Continue with the light tone above it and then the medium tone at the top of the canvas. Blend the tones lightly.

3. Paint the lefthand side of the hills with the dark sky tone and the medium sky tone on the right-hand side. Blend slightly. Keep the hills soft and rounded. When the hills or mountains are at a great distance, the third tone of the sky is used and painted in with the sky at the same time.

The field

Use the colour mix for tones of green on page 30.

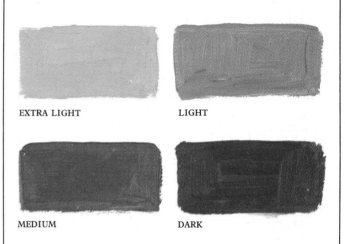

EXTRA LIGHT LIGHT

MEDIUM DARK

1. Mix the paint according to the instructions.

2. Paint the dark green tone on the lefthand side of the field, followed by the medium, light and extra light tones as you move towards the righthand side of the canvas. Keep the paint textured and uneven. Remember that the field is not a lawn. Blend the tones of green slightly.

3. Paint the dark green tone with the purple along the front of the field as indicated, giving the appearance of weeds and wild flowers. Use touches of blue and white for this.

4. Paint the dark green tone with purple under the trees for the shadows.

The trees

1. Study the trees in the painting on page 61.

2. The tree trunks in this painting will be painted in purple used straight from the palette.

3. Use the tones of green previously mixed for the field.

4. Paint in the small trees in the background, on the righthand side of the canvas, in the dark green tone on the lefthand side of the trees and in the medium tone on the righthand side. Use short strokes. Scratch the tree trunks unevenly with a knife when the paint is still wet.

5. Paint the tree trunks of the trees on the left unevenly spaced and not like little soldiers! Draw in the branches.

6. Paint the dark green of the foliage first, then the medium tone and the light tone on top of the mass. Keep the tones separated as shown in the painting. Keep the foliage uneven and loose.

7. Paint a little purple near the trunk on the foliage.

The houses

Paint these very small. Use the colour mixes for the extra light, medium and dark sky tones on page 22.

EXTRA LIGHT

MEDIUM

DARK

1. Paint a bit of the extra light sky tone on the front of the houses, and the medium tone on the side as indicated in the finished painting.

2. Paint the roof tops in Vermilion, which has been mixed with a bit of the dark sky tone.

Winter

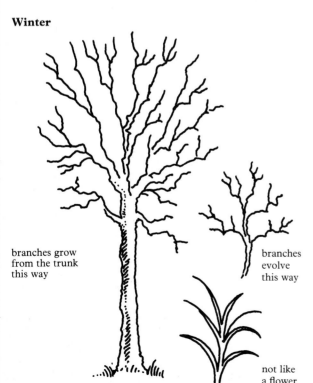

branches grow from the trunk this way

branches evolve this way

not like a flower

Summer

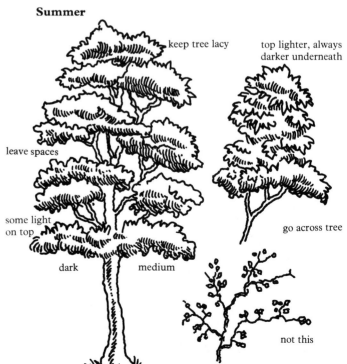

keep tree lacy

top lighter, always darker underneath

leave spaces

some light on top

dark medium

go across tree

not this

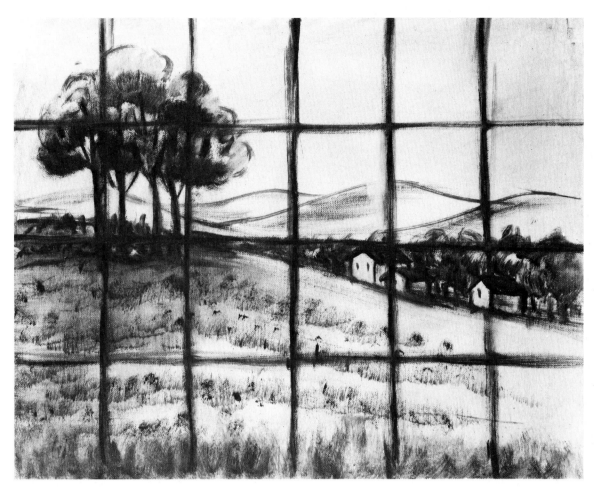

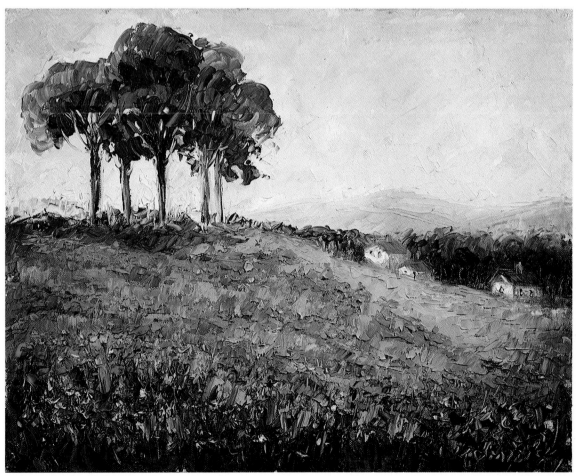

The poppies

Use the three tones of red straight from the palette without any mixing.

LIGHT (CADMIUM ORANGE)

DARK (ALIZARIN CRIMSON)

MEDIUM (VERMILION)

1. Paint tiny orange blobs of poppies on the right or light side of the field where indicated. Keep the poppies uneven and do not paint them in too thickly. Paint some Alizarin Crimson poppies here and there.

2. Paint Vermilion here and there underneath the orange blobs for shadows. Not too many!

3. Paint Vermilion blobs on the lefthand side of the field, with Alizarin Crimson blobs underneath for shadows.

4. Paint a few orange blobs here and there in the darker section of the poppies.

5. Remember to show the green of the field between the mass of poppies.

Index

Artists' materials
Artists' clear picture varnish 10
Brushes 8
Canvas 10
Canvas board 10
Cling film 10
Easel 10
Kerosene 8
Knives 7
Palette 8
Tin dipper 8
Tin foil 10
Toilet tissue 10
Tubes of paint 7
Turpentine 8
White spirit 8

Landscapes
Barn 31 *right*, 32 *left*
Brick 31 *right*
Building 31 *left and right*
Cloud 23 *left*, 31 *left*
Dirt road 24 *right*, 25 *left*
Earth 24 *right*, 32 *left*
Fence, metal 26 *left*, 30 *right*
Fence, wooden 24 *right*, 25 *left*, 31 *left*
Flowerpot 31 *right*, 33 *left*
Grass 27 *left*, 30 *left*
Hay 24 *right*
Hill 30 *left*, 25 *right*
House 23 *left*, 31 *left and right*
Lake 24 *left*, 37 *left*
Mountain 25 *right*, 32 *right*, 36 *left and right*
Road 23 *left*, 26 *left*
Rock 26 *left*, 33 *left*
Roof top 26 *left*, 31 *right*, 33 *left*
Sand 23 *left*, 24 *right*, 38
Shadow 25 *right*, 29 *right*
Shrub 30 *left*, 33 *left*
Sky, clear 22
Sky, stormy 23 *left*
Sky, sundown 23 *right*
Snow 31 *left*
Stone 25 *right*, 26 *left*
Street lamp 30 *right*
Train 30 *right*
Tree, foliage 30 *left*, 33 *left*
Tree, trunks 25 *left*, 29 *right*
Wood 24 *right*, 25 *left*

Seascapes
Boat 23 *left*, 31 *left*, 32 *right*
Boathouse 26 *left*, 31 *left*, 32 *right*
Cliff 25 *left and right*, 26 *left*, 33 *left*
Cloud 23 *left*, 31 *left*
Mountain 25 *right*, 32 *right*, 36 *left and right*
Pier 25 *left*, 26 *left*
Rock 26 *left*, 33 *left*
Sail 31 *left*
Sand 23 *left*, 24 *right*, 38
Sea 24 *left*, 37 *left*
Sea foam 22, 24 *left*, 37 *left*
Sea gull 31 *left*
Shadow 25 *right*, 29 *right*
Sky, clear 22
Sky, stormy 23 *left*
Sky, sundown 23 *right*
Tree, foliage 30 *left*, 33 *left*
Tree trunk 25 *left*, 29 *right*

Portraits
Eyes, blue 26 *right*
Eyes, dark 25 *left*
Flesh 38
Hair, dark 25 *left*
Hair, grey 31 *left*
Hair, light 24 *right*
Hair, red 31 *right*

Still life
Backgrounds, greyed burnt orange 31 *right*
Backgrounds, greyed yellow ochre 31 *left*
Backgrounds, greyed dark green 33 *left*
Backgrounds, greyed light green 32 *right*
Basket 32 *left*
Bottle of wine 30 *left*, 32 *right*, 33 *left*
Bowl 27 *left*, 31 *left and right*
Brass 27 *left*
Bread 24 *right*
Copper 31 *right*
Cup and saucer 23 *left*, 31 *left*
Eggs 38
Fish 23 *left*, 31 *left*
Glass 20, 21, 30 *left*
Highlight 19
Leaves and stems 30 *left*, 33 *left*
Lobster 28 *right*
Pewter 26 *left*
Soup tureen 24 *left*, 24 *right*, 31 *left*
Vase 27 *left*, 30 *left*, 37 *left*

Fruit

Apple 27 *right*, 28 *left*, 30 *left*
Apricot 34 *right*
Background, greyed burnt orange 31 *right*
Background, greyed yellow ochre 32 *left*
Background, greyed light green 32 *right*
Background, greyed dark green 33 *left*
Banana 27 *left and right*
Cherries 28 *left*
Grapes 29 *right*, 32 *right*
Lemon 27 *right*
Melon 34 *right*
Nuts 24 *right*
Orange 29 *left*
Peach 34 *right*
Pear 27 *right*, 30 *left*
Plum 29 *right*
Strawberries 28 *left*, 35 *left*
Watermelon, skin 30 *left*, 35 *left*

Vegetables

Artichoke 33 *left*
Aubergine 29 *right*
Background, greyed burnt orange 31 *right*
Background, greyed yellow ochre 32 *left*
Background, greyed light green 32 *right*
Background, greyed dark green 33 *left*
Broccoli 30 *left*
Brussels sprout 32 *right*
Carrot 29 *left*
Cauliflower 23 *left*
Corn on the cob 27 *left*
Courgette 30 *left*
Leaves and stems 30 *left*
Lettuce 30 *left*
Marrow 30 *left*
Mushroom 38
Onion 24 *right*
Onion, green 30 *left*
Pea 30 *left*
Pepper, green 30 *left*
Pepper, red 28 *right*
Potato 24 *right*
Pumpkin 29 *left*
Radish 35 *right*

Flowers

Anenome 28 *left*, 31 *left*, 36 *left*
Aster 31 *left*, 36 *left and right*
Azalea 21 *left*, 28 *left*, 35 *left and right*
Background, greyed burnt orange 31 *right*
Background, greyed yellow ochre 32 *left*
Background, greyed light green 32 *right*
Background, greyed dark green 33 *left*
Bluebell 26 *right*, 37 *left*
Carnation 28 *left*, 31 *left*, 35 *left and right*
Centre of flower 27 *left*
Chrysanthemum 27 *left*, 31 *left and right*
Crocus 27 *left*, 31 *left*, 36 *right*
Cyclamen 28 *left*, 35 *left and right*
Daffodil 27 *left*
Daisy 27 *left*, 31 *left*
Leaves and stems 30 *left*
Lilac 27 *left*, 29 *right*
Lily 27 *left*, 31 *left*
Marigold 27 *left*, 29 *left*
Nasturtium 27 *right*, 28 *left*, 29 *left*
Pansy 27 *right*, 29 *right*
Poinsettia 28 *left*
Poppy 28 *left*, 29 *left*, 35 *right*
Primrose 27 *left and right*, 34 *left*
Rose 27 *left*, 28 *left*, 31 *left*, 35 *left and right*
Sunflower 27 *left*
Sunflower, centre of 28 *right*
Tulip 28 *left*, 31 *left*, 34 *left*, 36 *left*
Violet 36 *left and right*
Zinnia 28 *left*, 29 *left*, 31 *left*, 35 *left and right*